Portrait of Long Island

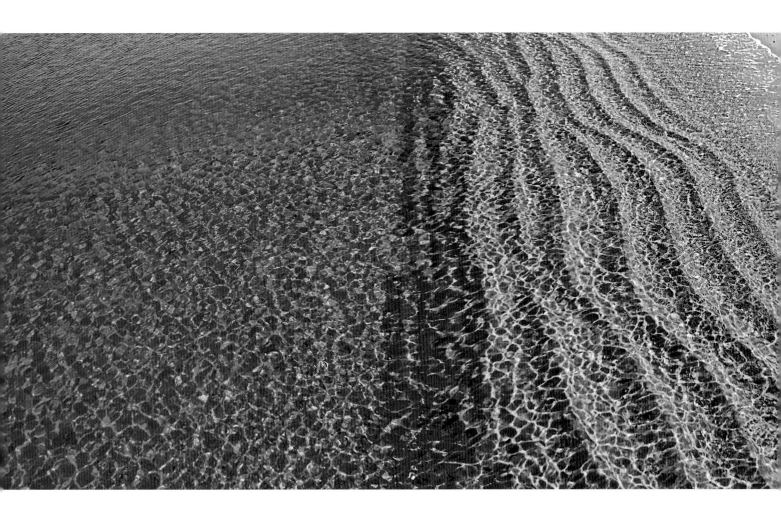

Portrait of Long Island
The North Fork and the Hamptons
Photographs by Jake Rajs

Essays by Jesse Browner and Paul Goldberger

The Monacelli Press

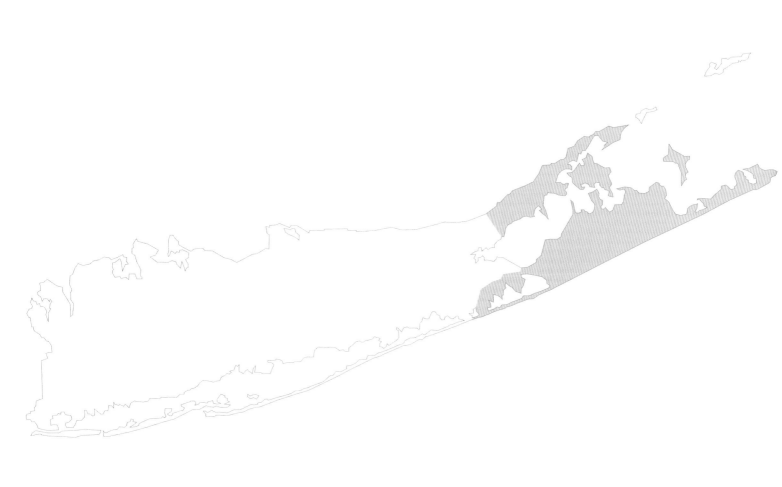

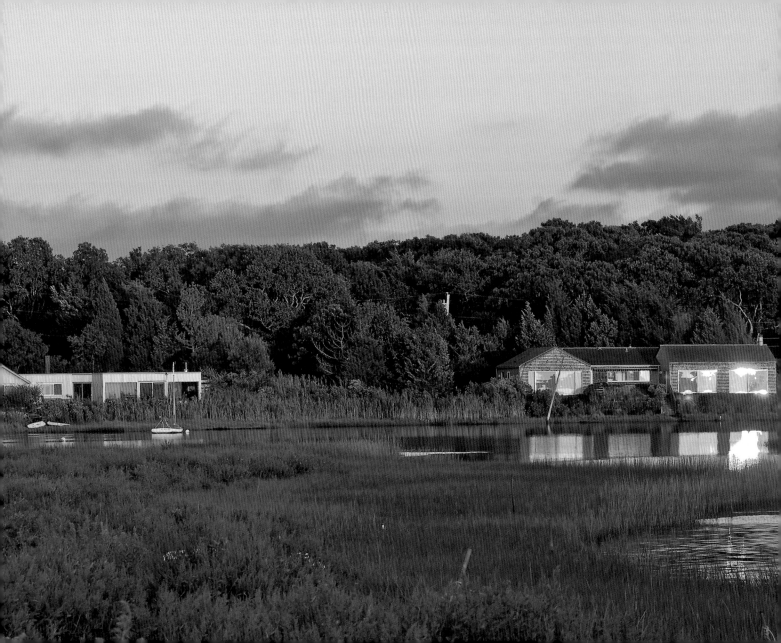

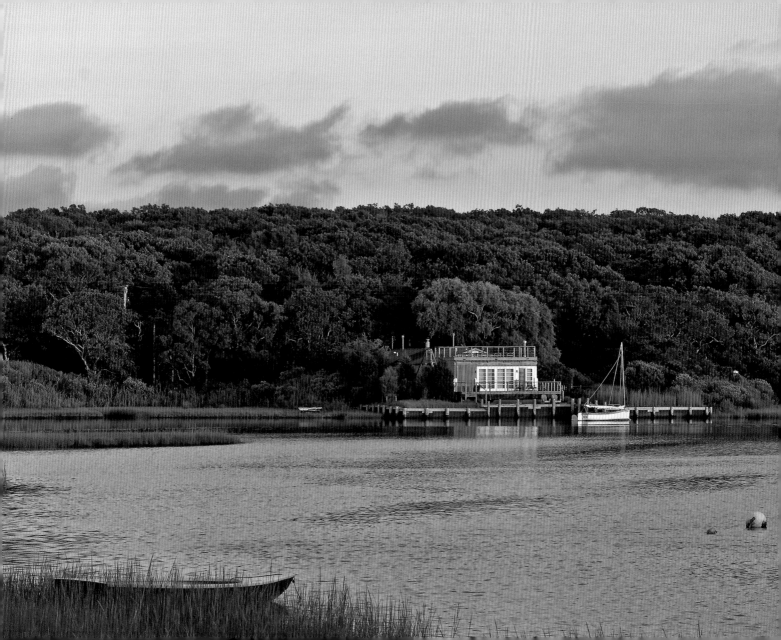

The North Fork

Jesse Browner

Paumanok, one of several Algonquin names for precolonial Long Island, was once believed to refer to the land's vague resemblance to a fish, as Walt Whitman famously pointed out in *Leaves of Grass*. The shape of the island does indeed resemble some sort of marine creature—a pilot whale, perhaps, or a shark—facing west, with Jamaica Bay as its mouth and the North and South Forks as its upper and lower tail fins, suspended between the Long Island Sound and the Atlantic Ocean. The mouth of the Peconic River, where it empties into Flanders Bay at the city of Riverhead, marks the dividing point between the twin forks. Between them lie Peconic Bay and its three islands: Robins, Shelter, and Gardiners. From Riverhead, the North Fork extends like a great spindly finger some forty miles eastward, ending at Plum Gut, a turbulent channel of water between Orient Point and Plum Island. Beyond that are Block Island Sound and the open Atlantic.

By far the most common way of entering the North Fork is to drive the length of the Long Island Expressway to its terminus at Riverhead, and then to take the old colonial road, Route 25, all the way to the point. It is not an auspicious beginning, as the Riverhead segment of Route 25 is lined today by mile after mile of strip malls, factory outlets, big-box stores, and auto dealerships. But then something unexpected, and almost miraculous, happens near the Southold town line. Four lanes narrow to two, the road begins to dip and curve as a country road should, and development gives way to farm stands, church steeples, plowed fields, orchards, vineyards, and quaint—but not too quaint—hamlets and villages. On the journey through Laurel, Mattituck, Cutchogue, Peconic, Southold, Greenport, East Marion, and Orient, the last fifty years or so seem to melt away until, at last—even if this is your very first visit—you begin to understand why childhood memories retain their golden fondness deep into disillusioned adulthood. For this is where it all began. This is how it was, and how it is, and how it may yet survive to be.

It is precisely that quality of the land—simultaneously timeless, in the moment, and embellished by memory—that Jake Rajs captures in his photography. His vision propels us upward to the restless sky, outward to the unfathomable sea, and inward to the slumbering soul.

As you push on eastward, the contours of the land begin to make themselves felt. To the south, deep inlets, lined with salt grass and stands of white oak and swamp maple, push inland from the bay

almost to the road. To the north, vast flat, open fields rise gently to the wooded bluffs overlooking the Sound. At Dam Pond, between East Marion and Orient, the wasp-waisted peninsula contracts to the width of the causeway, bringing Connecticut, Shelter Island, and Montauk into stunning, simultaneous view. It then widens out into wooded hills to the north and broad, flat fields to the south, many reclaimed long ago from aboriginal wetlands and none more than a few scant feet above sea level.

Nowhere on the North Fork are you ever more than a mile or two from the water; its presence is the one overwhelming constant of North Fork reality, from the comparative mildness of its winters and the pale translucence of its light to the ubiquity of boatyards, fish markets, and dinghies for sale roadside. Water defines the North Fork the way a mountain is defined by its own slopes, both delimiting it from and connecting it to all that surrounds it. It is not always easy to determine where one begins and the other ends.

Water has been the North Fork's defining element since the very beginning. During the last ice age, the Wisconsin Glacier extended from Canada to its terminal position down the central spine of Long Island. Over the millennia, the glacier advanced and retreated, scouring the land and creating outwash plains and recessional moraines, including the one that defines the Sound shore of the North Fork. When the glacier retreated definitively back to Connecticut some twenty thousand years ago, it left behind kettle lakes and some of the richest, deepest stone-free soil

on the East Coast. It did not take long for the native peoples of the region, themselves recent arrivals from Asia and the North American west, to discover and exploit the pristine natural bounty of their new, and newly temperate, home. This was the first and last time that the word "discover" could be used in its fullest sense in relation to the migration of nations through North America.

The four Algonquin-speaking tribes of the East End—the Shinnecock and Montauk of the South Fork, the Manhanset of Shelter Island, and the Corchaug of the North Fork—could plausibly have served as the models for the archetypical, or stereotypical, peaceable children of nature painted by early European colonists. On the North Fork especially, they had everything they could possibly desire for a full, healthful, prosperous existence. The bays provided an essentially limitless supply of porgy, weakfish, flounder, fluke, alewives, and turtles; vast underwater beds of eelgrass nurtured scallops, oysters, clams, mussels, and crabs. Corn, fertilized by menhaden seined from the shallows, grew readily and in abundance. Dense forests of oak, maple, and white pine were rich and uncontested foraging and hunting grounds, teeming with white-tailed deer and wild turkey. The related tribes were at peace with one another and held a virtual monopoly on purple and white wampum, cylindrical beads painstakingly manufactured from the shells of quahogs and traded as far west as Ohio. For centuries, the only dark cloud on the Corchaugs' horizon was the recurrent threat of raids by the Pequots, their overlords across the Sound in Connecticut, as

commemorated in the real meaning of the name Paumanok—"land of tribute."

By the 1630s, the Dutch in New Amsterdam and the English of the Massachusetts Bay and New Haven colonies had been trading with the East End natives for a decade, but their dreams of establishing permanent colonies there remained stymied by the warlike Pequots. Only when the Pequots were decimated by war in 1637 did it become possible for the Europeans to expand into eastern Long Island. In 1640, the Reverend John Youngs, a native of Southwold, in Suffolk, England, led a small group of nonconformists from New Haven into Peconic Bay and founded Southold, the oldest English town in New York (a claim that remains disputed by Southampton). Although they had a strongly stockaded village—the remains of which can still be seen by Down's Creek on Fort Neck—Corchaug resistance was nonexistent, and the natives were soon confined to a small reserve on Indian Neck. When even that was denied them, they seemed to melt away like spring snow. The last Corchaug, David Hannibal, died in 1936.

What the English found on the North Fork were not the typical hardscrabble challenges encountered by most early colonists. The Corchaugs had cleared hundreds of acres of prime farmland—known locally as the "Broad Fields"—sparing their usurpers the arduous task of hacking farmland out of the primeval forest. The creeks were lined with ample provision of salt hay for the newcomers' plow horses; freshwater springs were abundant; the woods offered fine mature oak for housing and white pine for shipbuilding. With all these riches at their disposal, the New Haven colonists rapidly spread across the peninsula and most readily adapted themselves to the lives of prosperous, settled farmers and landowners, raising wheat, rye, and corn. For the next 250 years, the North Fork essentially slept, the principal thrust of its historical trajectory reflected in the catalog of land transfers among the descendents of the original settlers, whose names—Horton, Wickham, Tuthill, Wells, Latham—dominate local politics, farming, and tombstone inscriptions to this day. In the words of local historian Wayland Jefferson, "There are no epic adventures to be told and no pretense is made that this history recounts events of major importance."

Of course, no history, however supine, is entirely without defining moments, and even that of the North Fork has a few of its own. In 1664, Southold was compelled—very reluctantly—to sever its ties to Connecticut and become subject to the Duke of York and thus, eventually, a part of New York state. In the 1690s, Captain Kidd plied the waters of the bay, burying his treasure somewhere on or near Gardiners Island. Throughout the Revolutionary War, Southold remained under British occupation; while many of its inhabitants were loyalists, more than half fled to Connecticut. In 1838, the hamlet of Winter Harbor incorporated and changed its name to Greenport, becoming home port to a large whaling fleet that prospered throughout the early and mid-nineteenth century. In 1844, the railroad came to the North Fork, with its terminus at Greenport, opening markets for local produce in New York City and

bringing the first tourists. By the late nineteenth century, Orient had become a popular and sophisticated resort, and artists had begun to settle in Peconic, including Edward August Bell and Irving Wiles, founder of the Peconic school. Albert Einstein spent several summers in Cutchogue in the 1930s.

And that's about it. Though not entirely unaffected by world events, the people of the North Fork remained essentially untouched by most of the revolutionary changes that roiled the rest of civilization through those turbulent centuries.

But change slowly began to make itself felt in the modern era. With the waning of the whaling industry, the North Fork economy was primarily agricultural, with potatoes as its mainstay. Irish and Polish farmers moved in for the first time in the early twentieth century, just as competition from newly opened lands in the West inaugurated a steady decline in prices.

Cauliflower and asparagus were reliable cash crops for a time, but cheap Californian produce soon made them unprofitable as well. By the 1950s, with land values soaring and potato prices plummeting, the old farming families began converting to fruit and industrial sod, or selling out to developers. The original Wickham farm fell to a golf course. A planned extension of the Long Island Expressway would have plowed a six-lane highway through the heart of the North Fork to a suspension bridge extending from East Marion to Old Saybrook, Connecticut, effectively destroying the region's rural character. Although community opposition and high costs scotched the Atlantic Expressway, development

pressures and the ongoing hardships of the farming community seemed destined to extend the suburbanization of central Long Island to its easternmost extremity.

And then, in 1973, John Wickham sold seventeen acres of potato field to Alex and Louisa Hargrave. The Hargraves had something special in mind for their tiny farm—something that represented both the continuity of the land's age-old agricultural traditions and a bold, even reckless innovation. The North Fork, with so little history of its own, suddenly had a unique new future before it.

In 1975, the Hargraves opened their winery, the first on Long Island, with seventeen acres of cabernet sauvignon, pinot noir, and sauvignon blanc. Twenty years later, thirty-five commercial vineyards accounted for 1,800 acres of former potato fields; by 2006, that number had grown to sixty vineyards and 4,000 acres; and it continues to grow with considerable international investment. As Louisa Hargrave has noted, it is a perfectly natural confluence: "Long Island wines are grown in a cool, temperate climate that protects the elements that make aromatic, smooth, highly energized wines with great natural balance."

It could reasonably be argued that the triumph of wine production has been one of the single most pivotal events in the history of the North Fork since the arrival of the railroad, or even of the first English colonists. Many would no doubt take exception to the notion that the arrival of the vineyards saved the North Fork, but there's no denying that, as local journalist Denise Civiletti rightly points out, "Long

Island wineries [have become] central players—if not the central players—in our evolving North Fork economy."

Before the Hargraves, suffering farmers had few willing takers for their increasingly valuable land other than developers. Today, with conservation easements, land trusts, and tax incentives, vast tracts that might otherwise be lost forever are being preserved for agriculture. The preservation of the land and the growing environmental consciousness of those who control it have led, in turn, to a sudden—some might say fervid—interest in the North Fork among tourists, and especially wealthy weekenders from New York City, who a decade ago might not even have been able to place it on the map. The North Fork had been "discovered"—again. While that, understandably, might not sit well with those who are being priced out of their ancestral homeland, there is no doubt that it has created a viable, self-sustaining, and vibrant economy that will ensure the survival of all that makes the peninsula unique in the first place—its beaches, its wetlands, its villages, and its waters.

It is a sea change that is still in the making, and no one knows where it may all lead. Given the North Fork's vast, largely untapped potential as an idyllic leisure ground so close to the country's greatest city, it may all seem inevitable in retrospect. Those who have been in on its secrets want to preserve their Brigadoon as they always knew it; newcomers stand mouth agape at its splendors and seek to put their own stamp on it. The process seems to have settled into a comfortable compromise on the North Fork. On the North Fork, old and new seem, for now, to be cohabiting harmoniously and fruitfully—a phenomenon movingly rendered in Jake Rajs's photographs.

There are, as of this writing, no bottlenecks on the LIE off-ramps, byways remain blissfully clear even in the high season, and day-trippers may still find themselves sharing the road with a laconic tractor or two. On any given summer's day, it is still not unusual to find oneself entirely, almost preternaturally, alone on a great stretch of white sandy beach, disturbed only by the urgent passage of Canada geese. The local kids still fish and leap from the public dock at the end of Greenport's Fifth Street, as they have always done. Victorian manors still share the waterfront with unwinterized bungalow colonies that have been there since they were giving it away. The fishing fleet, though reduced, is still an intrinsic part of the local economy, and small boats still pull up behind Alice's Fish Market at dawn each day to unload their catch. It remains very difficult to find a hip nightclub anywhere in the vicinity—let alone a publicist or a paparazzo—and those hoping to do a little celebrity spotting may have to content themselves with one of the reclusive architects and artists who have colonized Orient village. All that may change as the money and the monied continue to pour in, but for the moment, at least, the North Fork remains what it has always been—a sleepy, dappled, and blessed backwater. The North Fork has awakened, it is true, but it is still basking in the golden mist of its ancient slumber, somewhere between a dream and a sunrise.

North Fork

Riverhead
Mattituck
Cutchogue
Peconic
Southold
Greenport
East Marion
Orient

Shelter Island

Shelter Island Heights
Dering Harbor

South Fork

Westhampton
Quogue
Hampton Bays
Shinnecock
Southampton
Water Mill
Bridgehampton
Sagaponack
Sag Harbor
Springs
East Hampton
Amagansett
Montauk

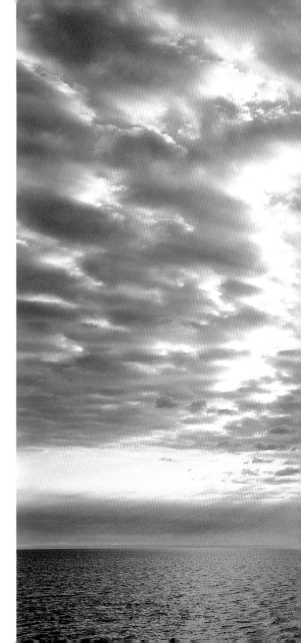

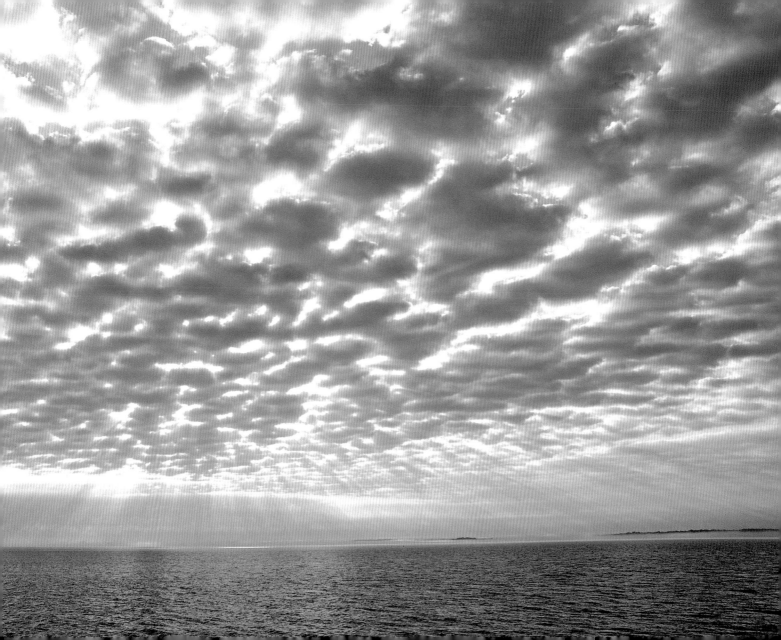

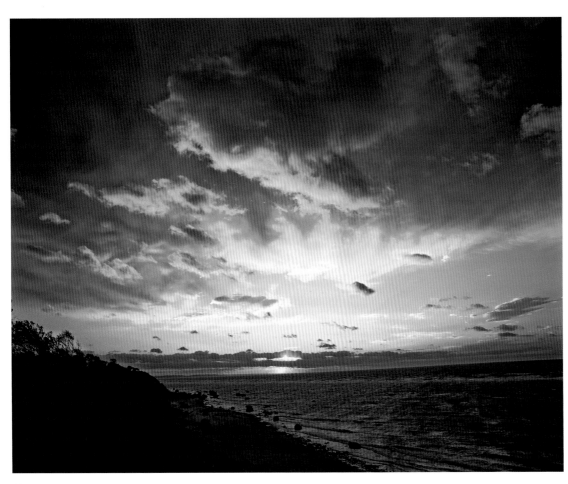

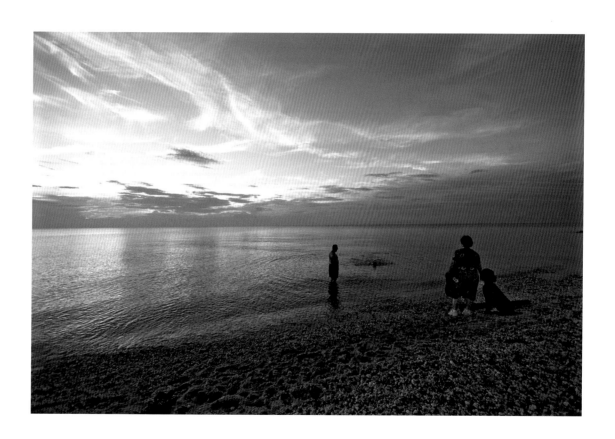

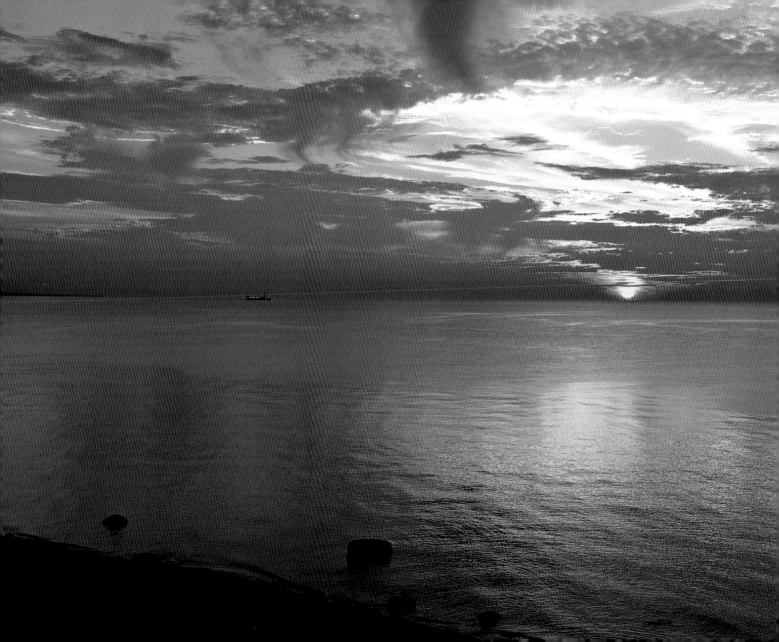

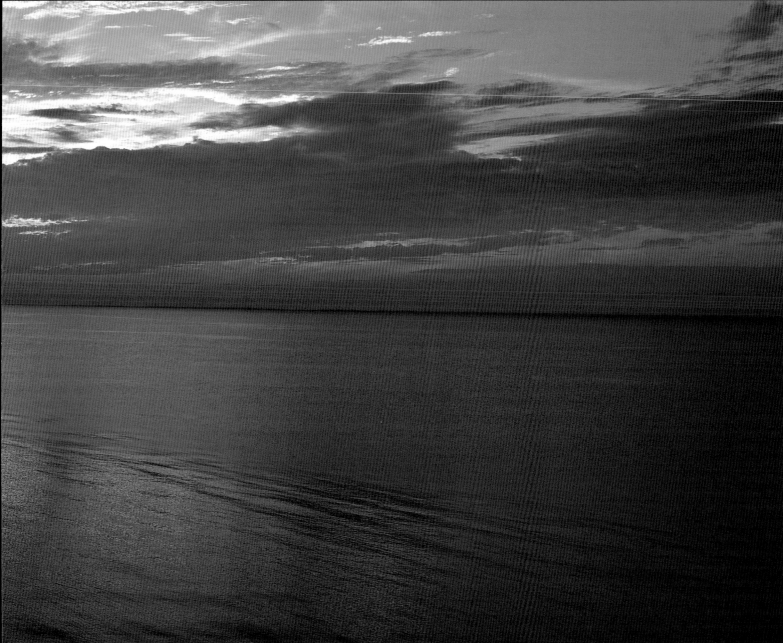

(preceding pages) **Birch Beach** Cutchogue
Dignans Road Cutchogue

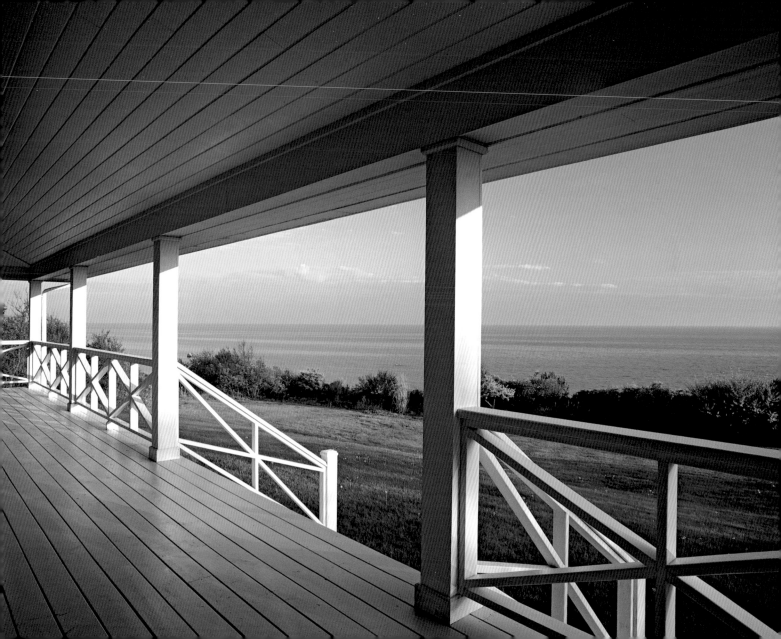

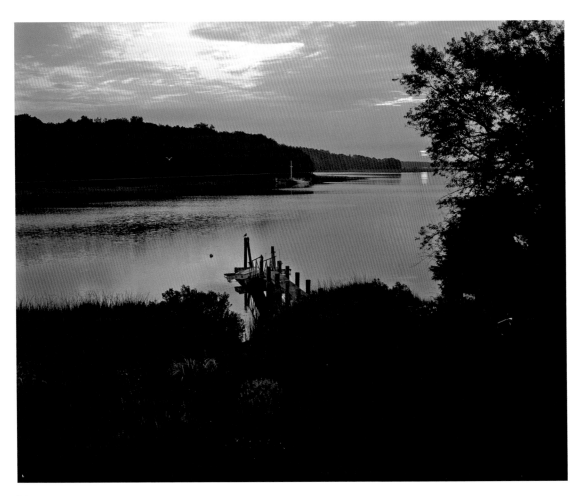

Peconic
Cutchogue Harbor New Suffolk

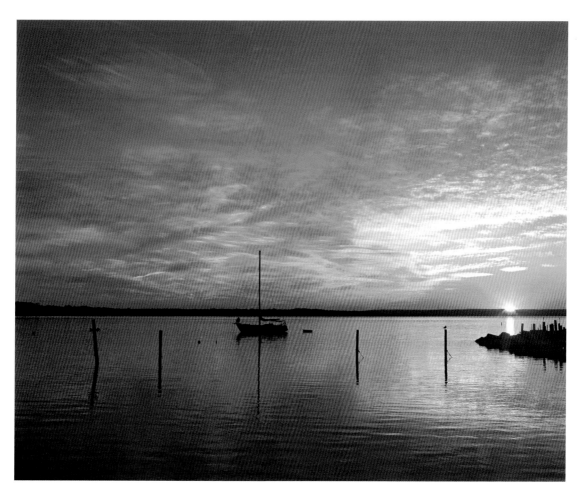

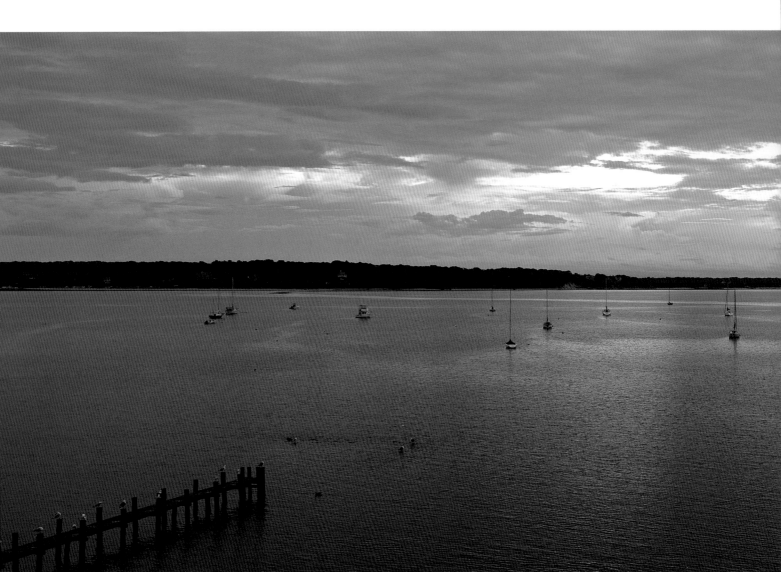

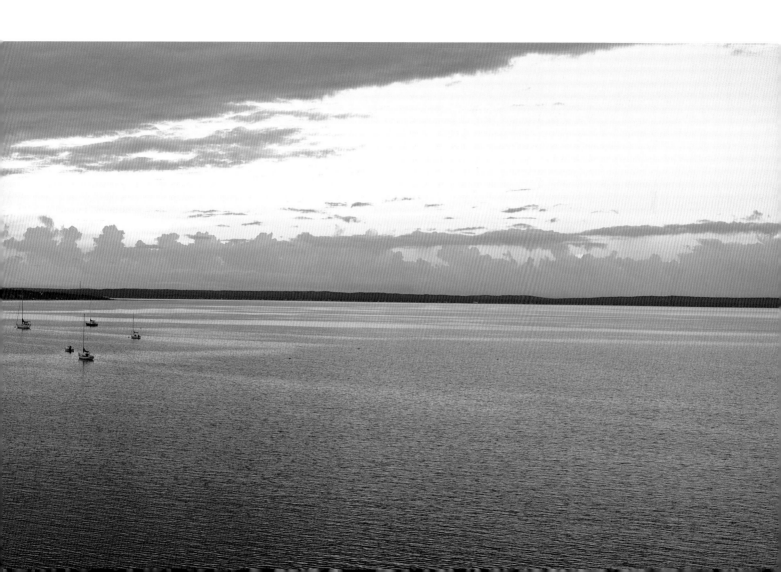

Birch Beach Cutchogue

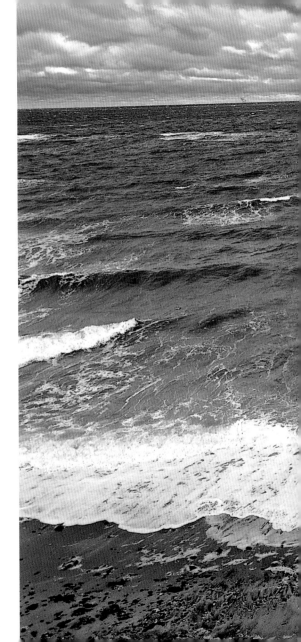

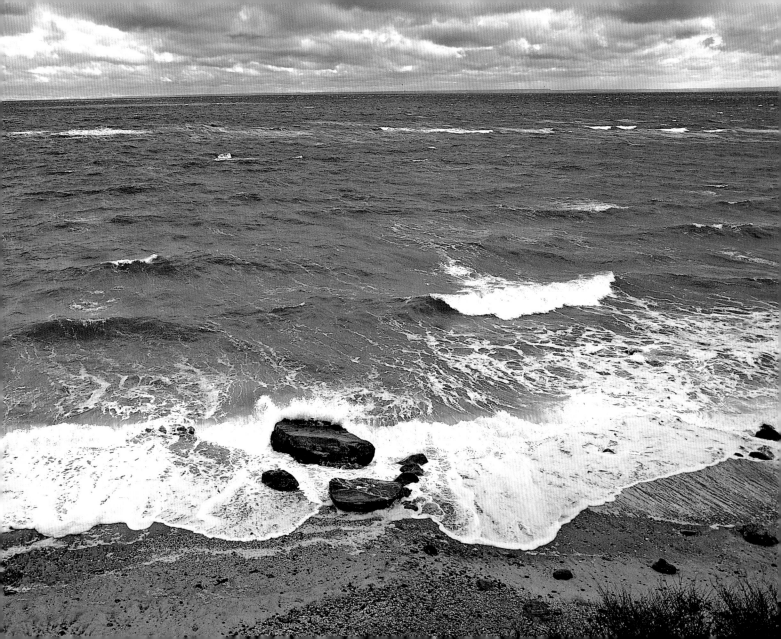

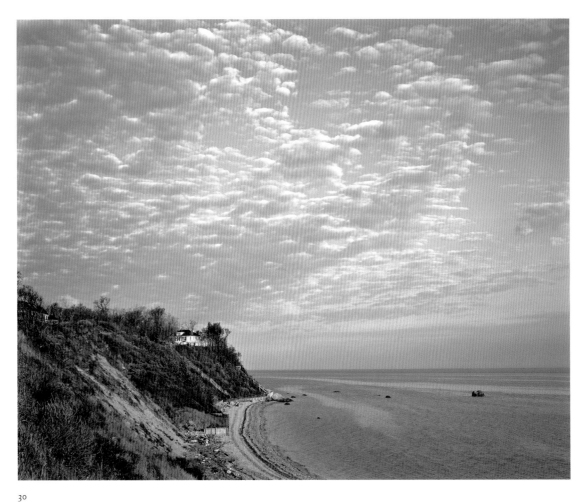

Bluffs Cutchogue
Mattituck

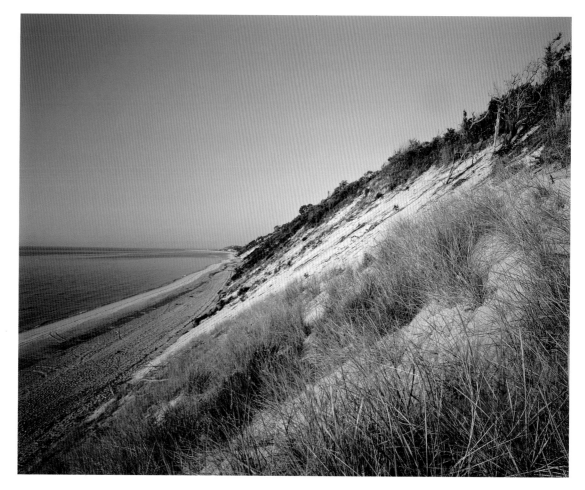

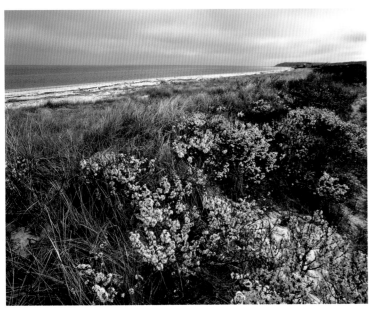

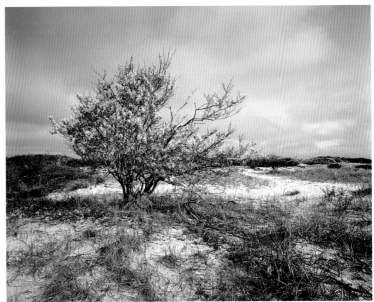

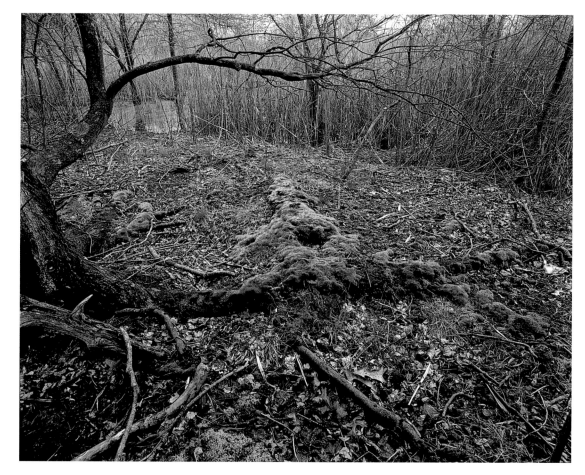

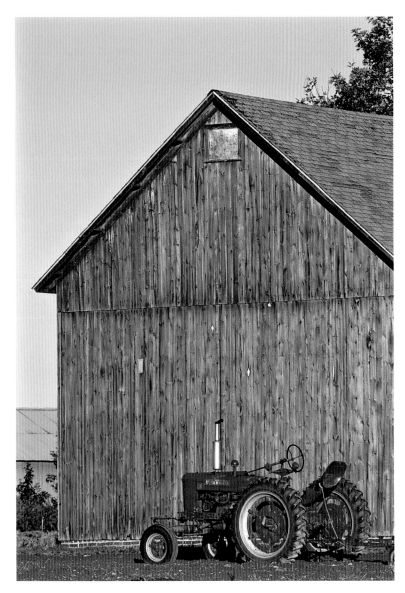

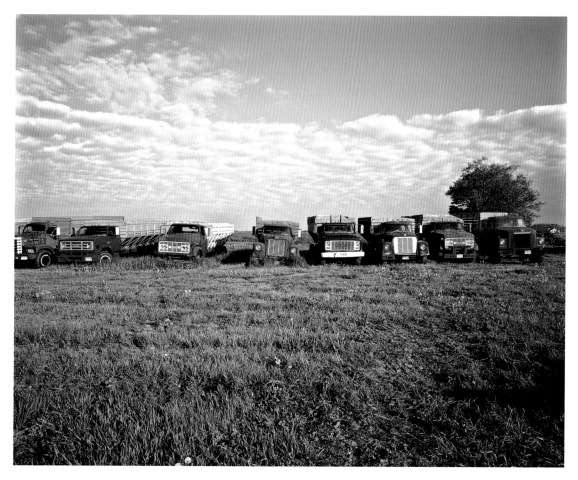

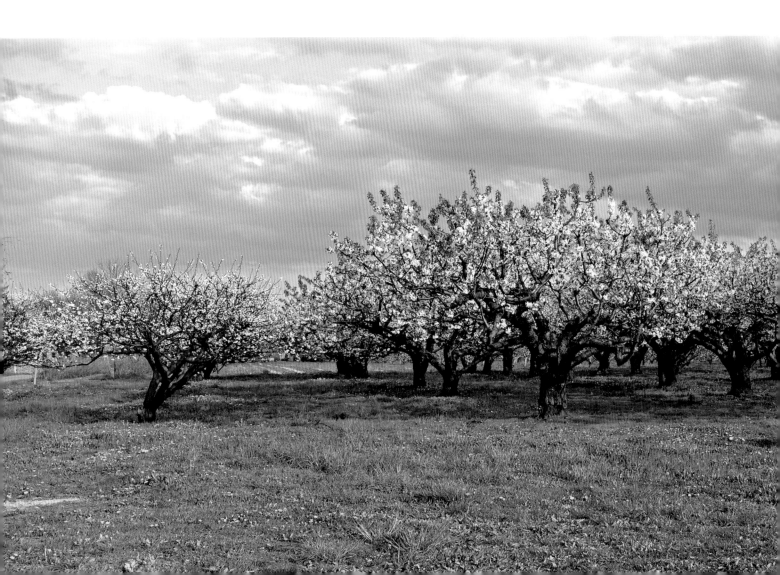

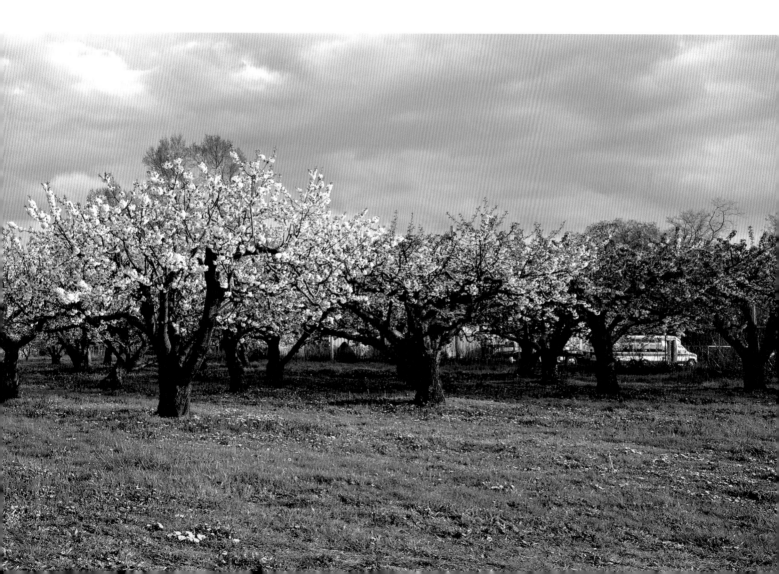

Schreiber Farm, Oregon Road Cutchogue

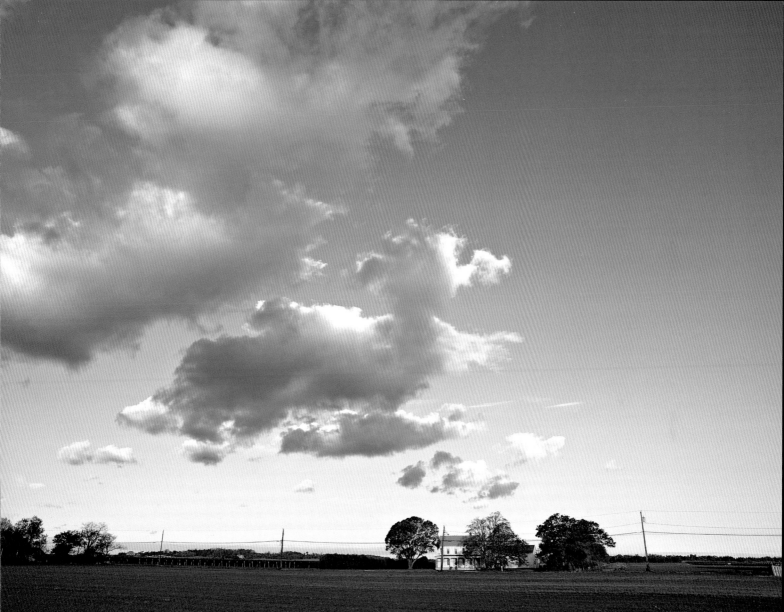

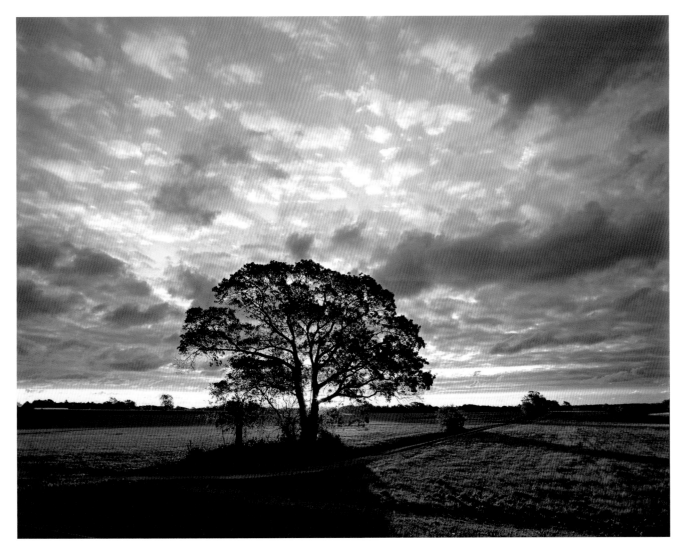

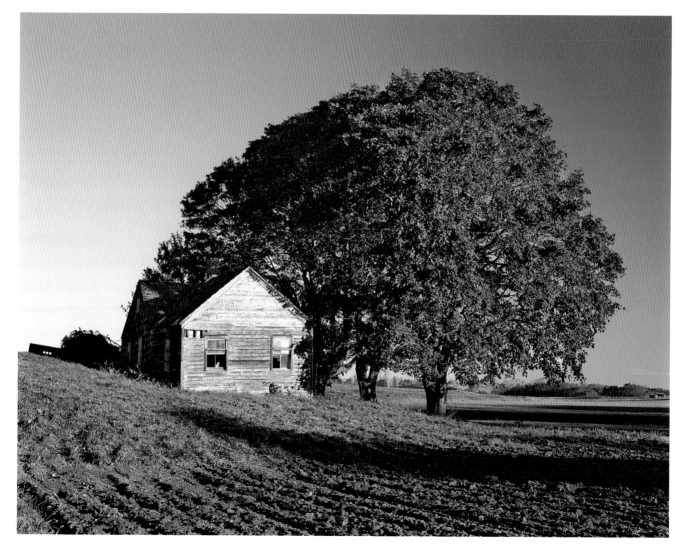

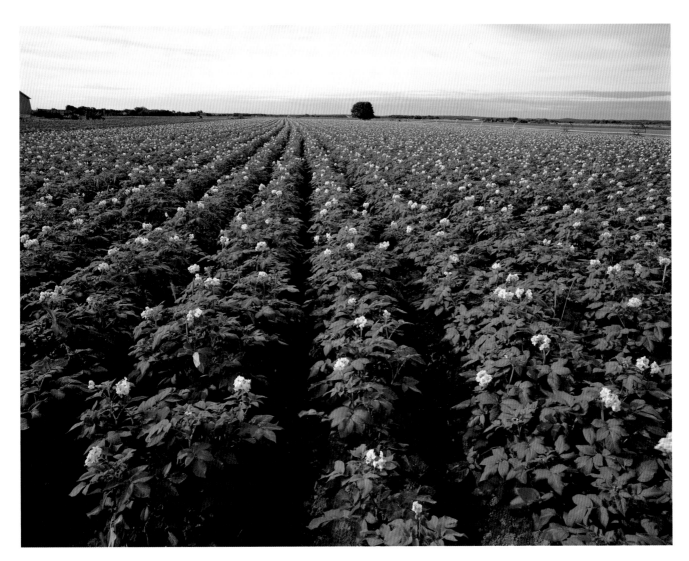

Potato field Riverhead
Roanoke Farm Riverhead

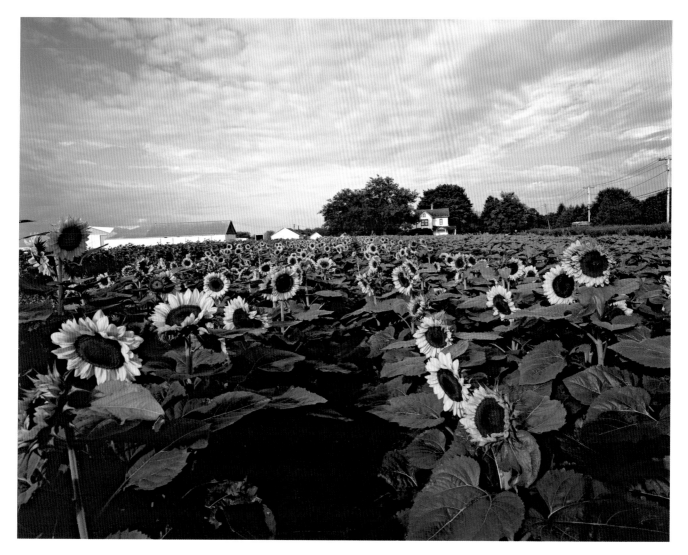

Half Hollow Nursery Laurel
(following pages) **Osprey's Dominion Winery** Peconic

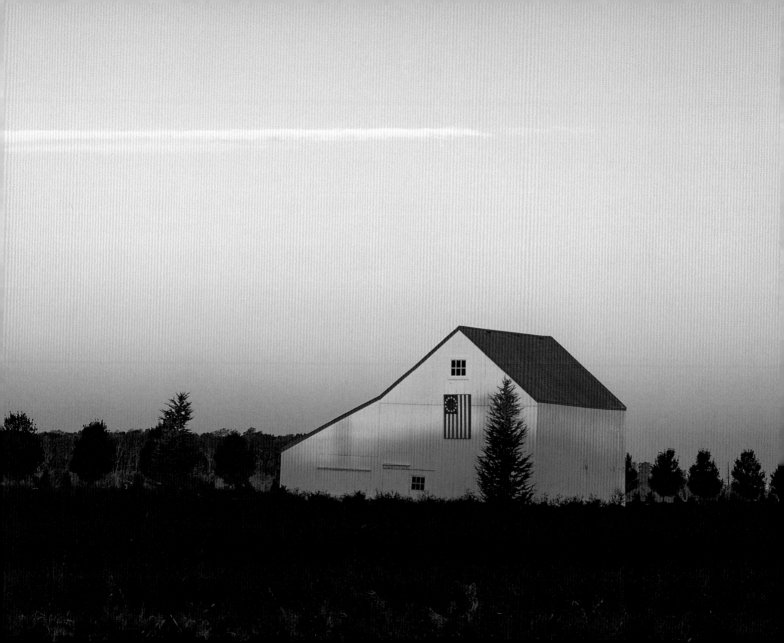

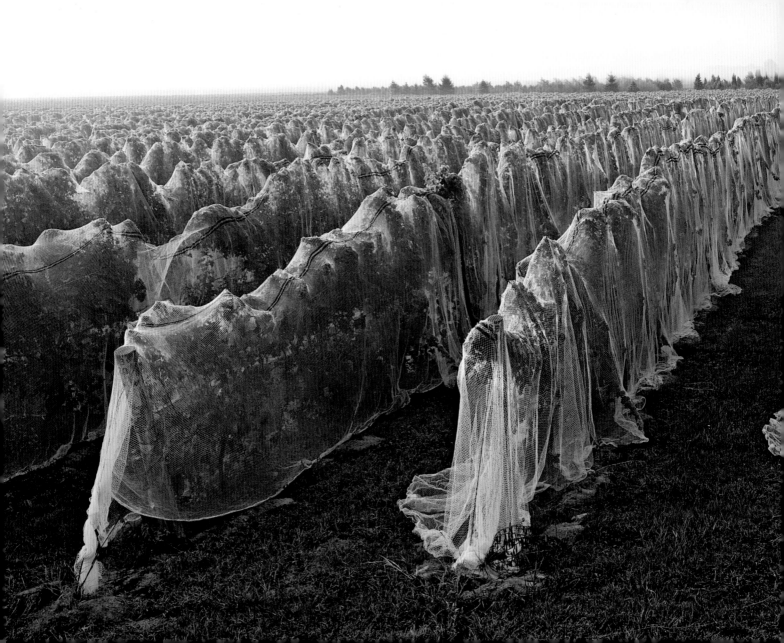

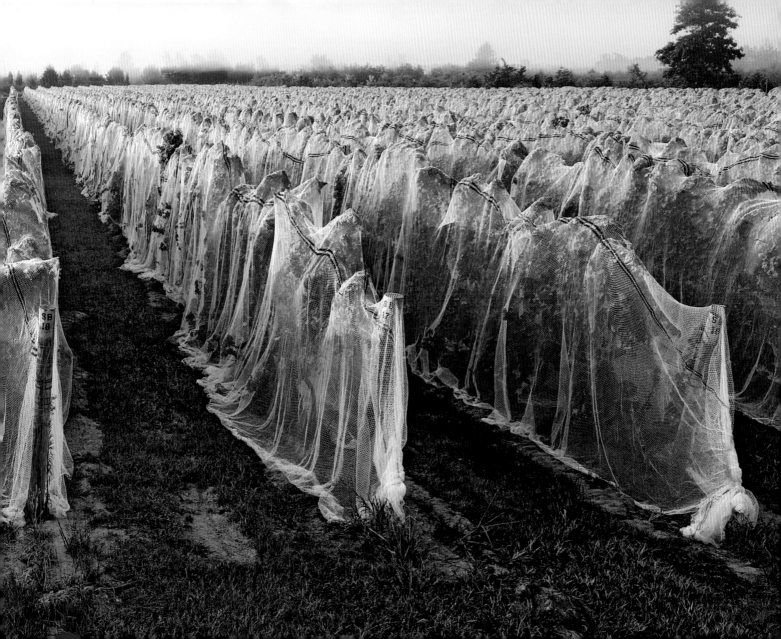

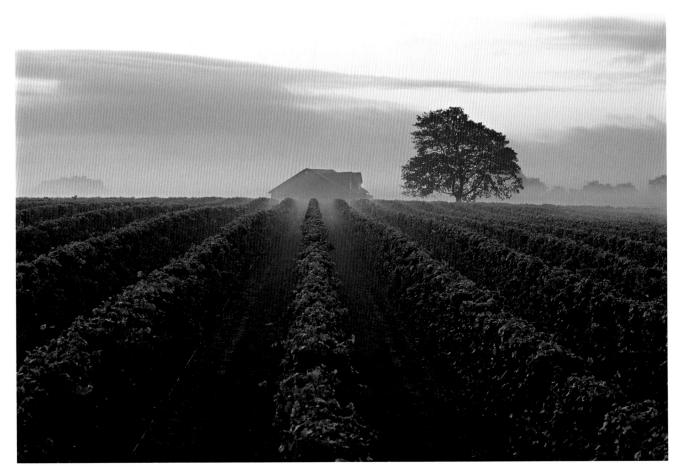

Duck Walk Vineyards Cutchogue
Martha Clara Vineyards Jamesport

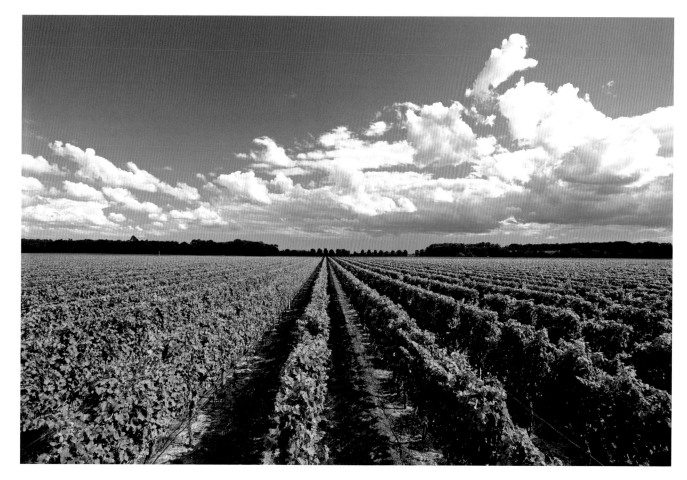

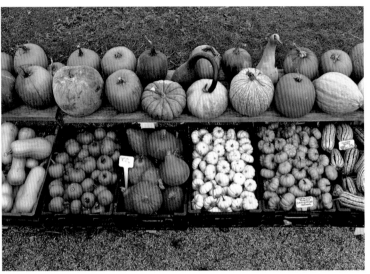
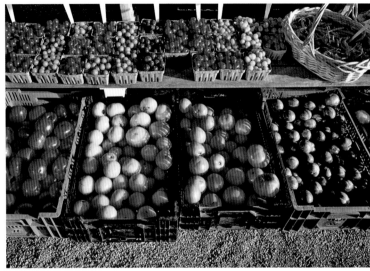

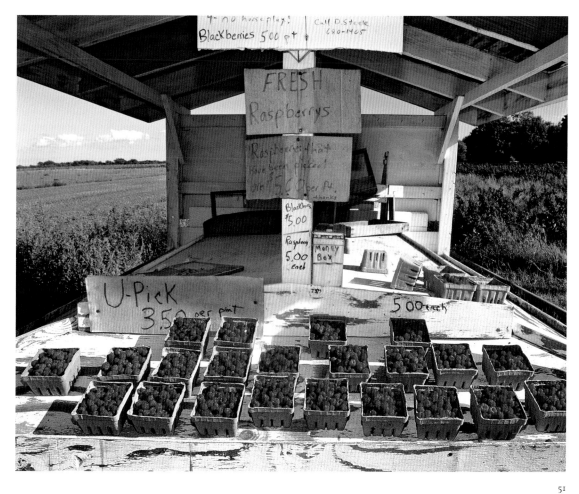

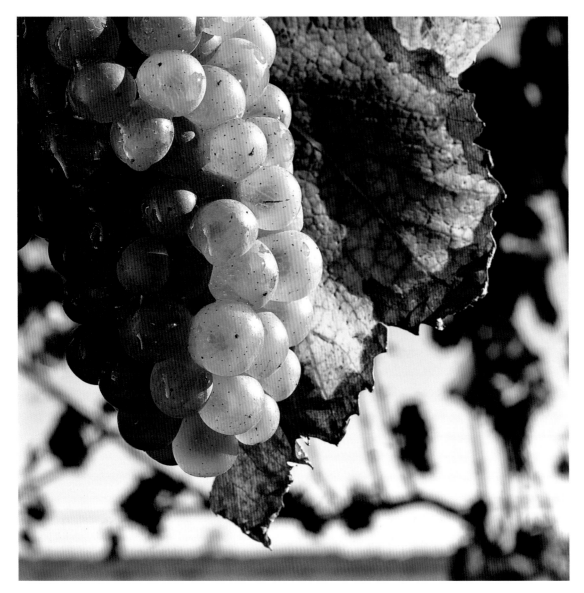

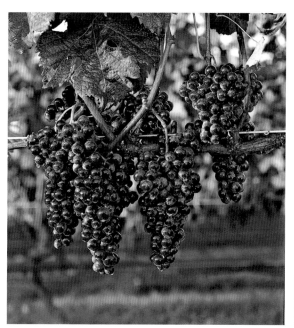

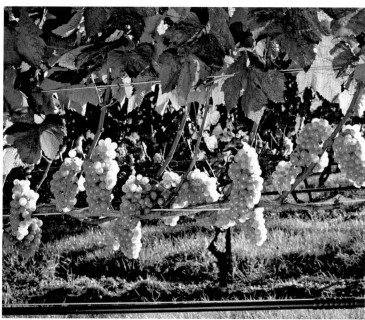

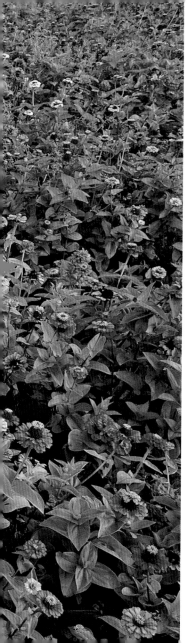

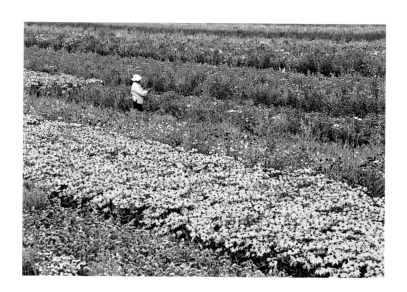

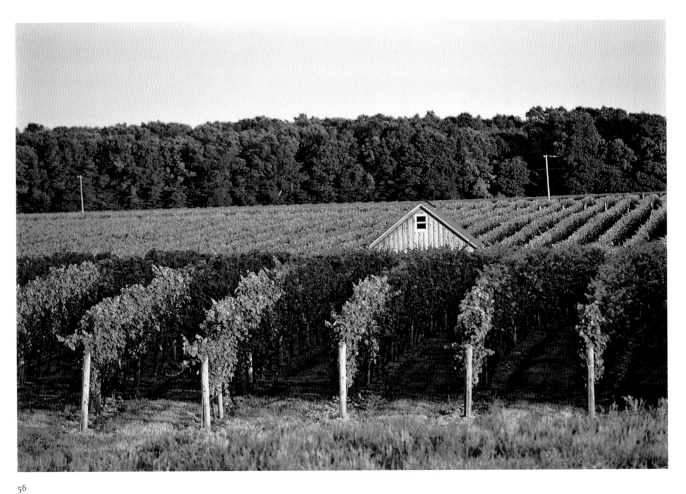

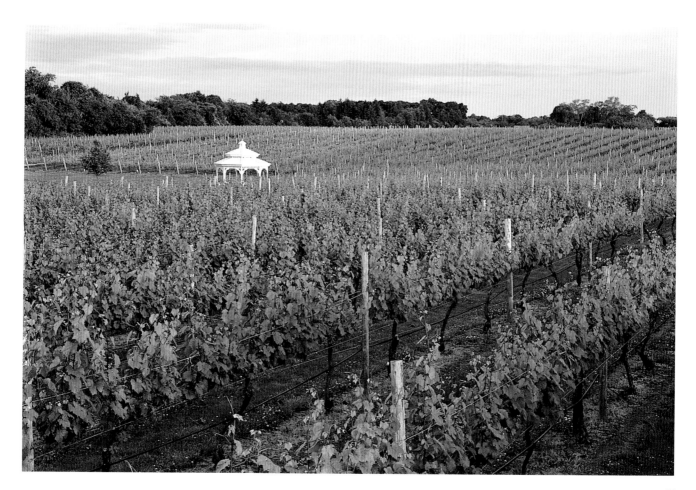

North Fork	Shelter Island	South Fork
Riverhead	Shelter Island Heights	Westhampton
Mattituck	Dering Harbor	Quogue
Cutchogue		Hampton Bays
Peconic		Shinnecock
Southold		Southampton
Greenport		Water Mill
East Marion		Bridgehampton
Orient		Sagaponack
		Sag Harbor
		Springs
		East Hampton
		Amagansett
		Montauk

Orient Point

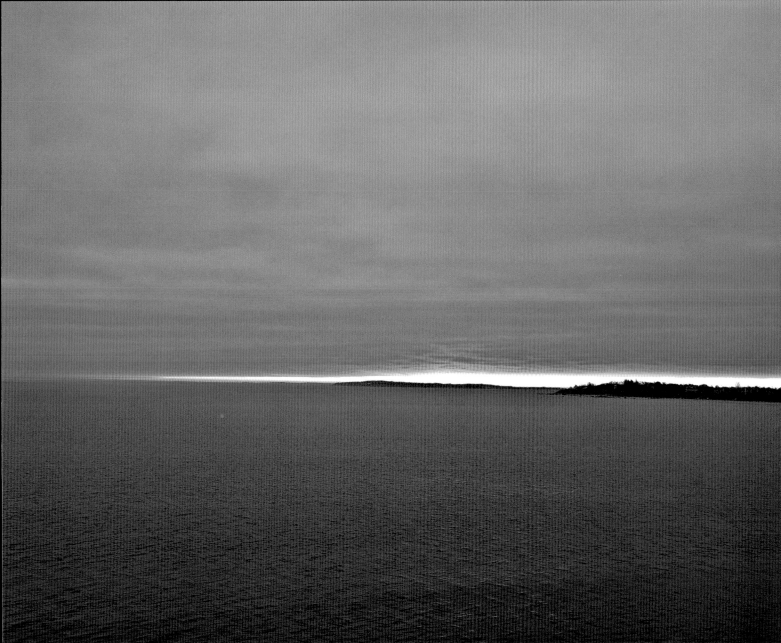

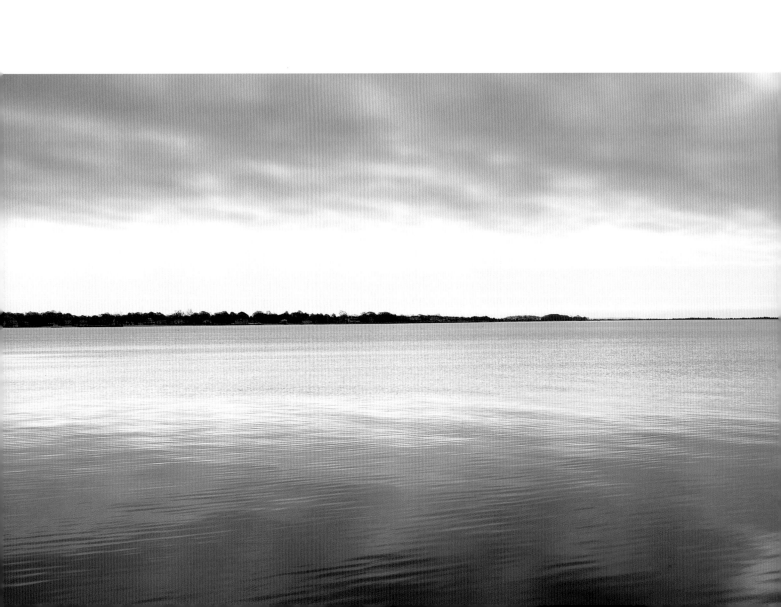

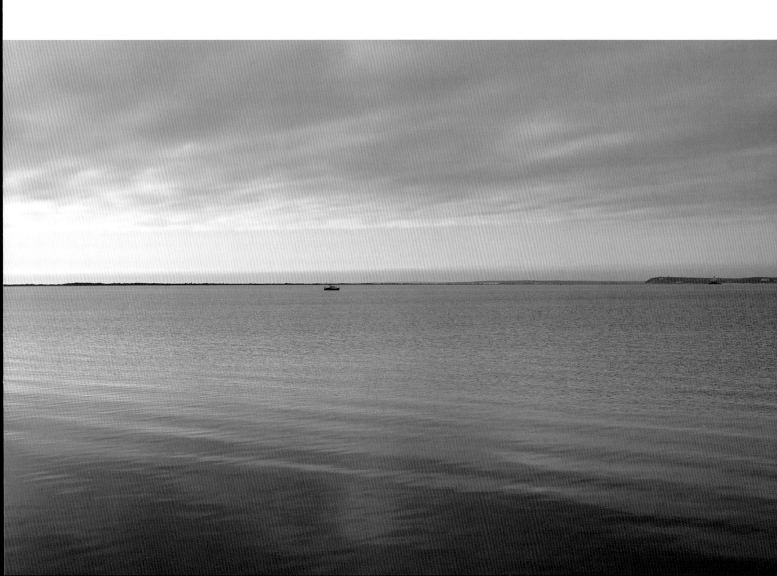

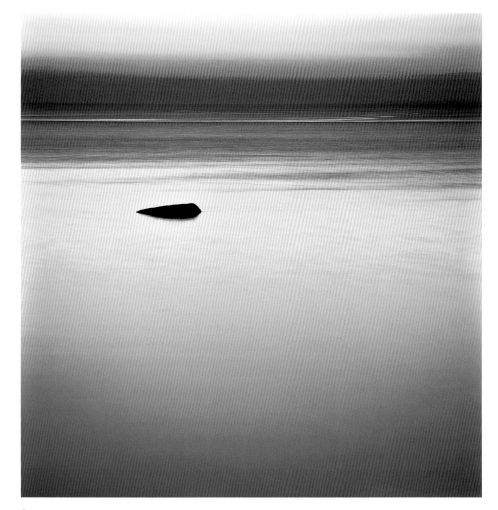

Southold
Orient

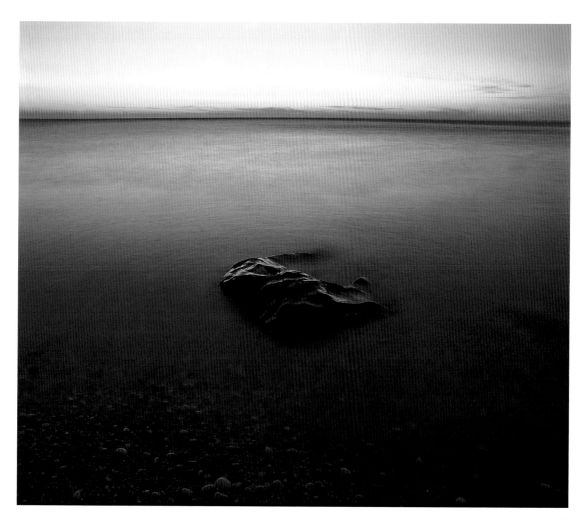

Orient

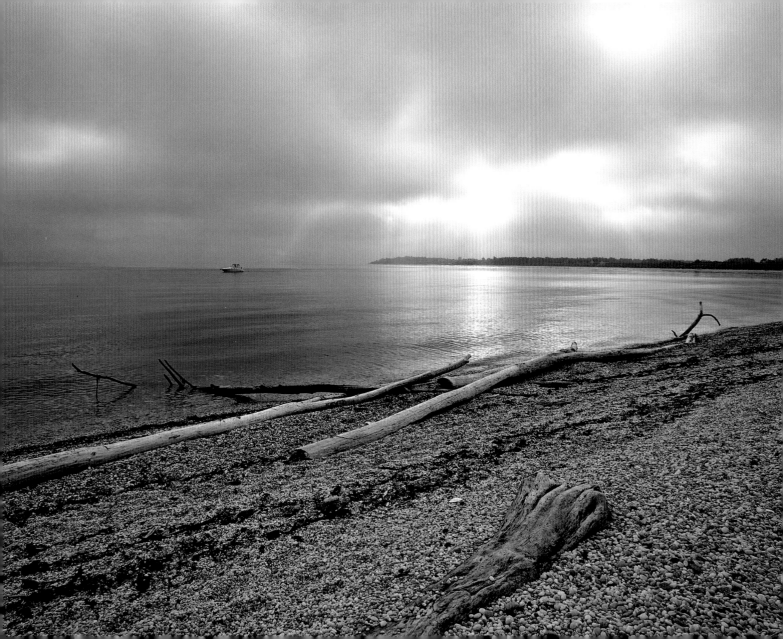

Town Beach Southold

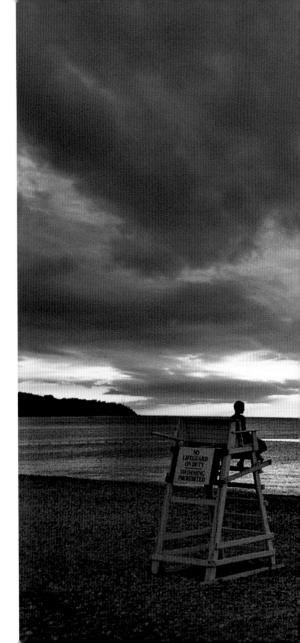

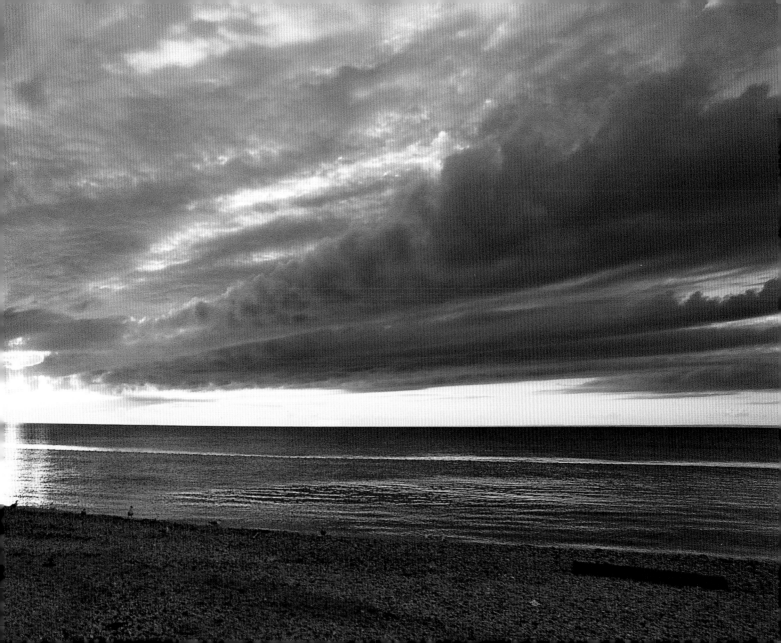

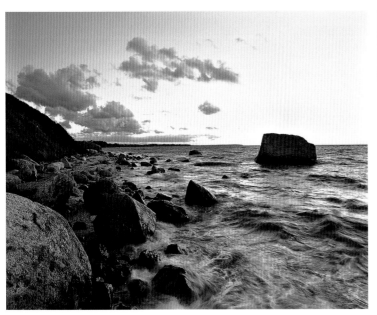
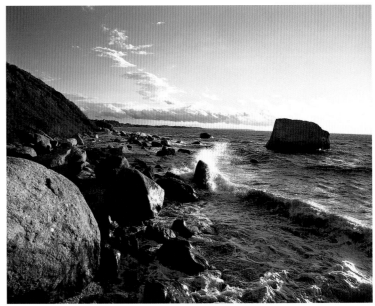

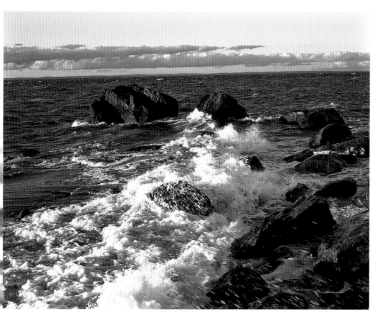

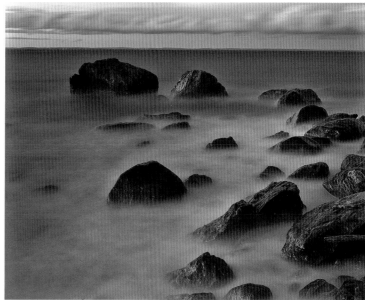

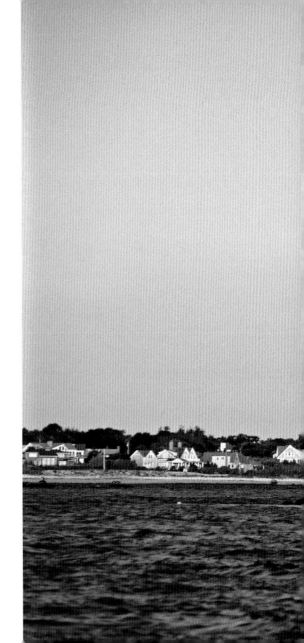

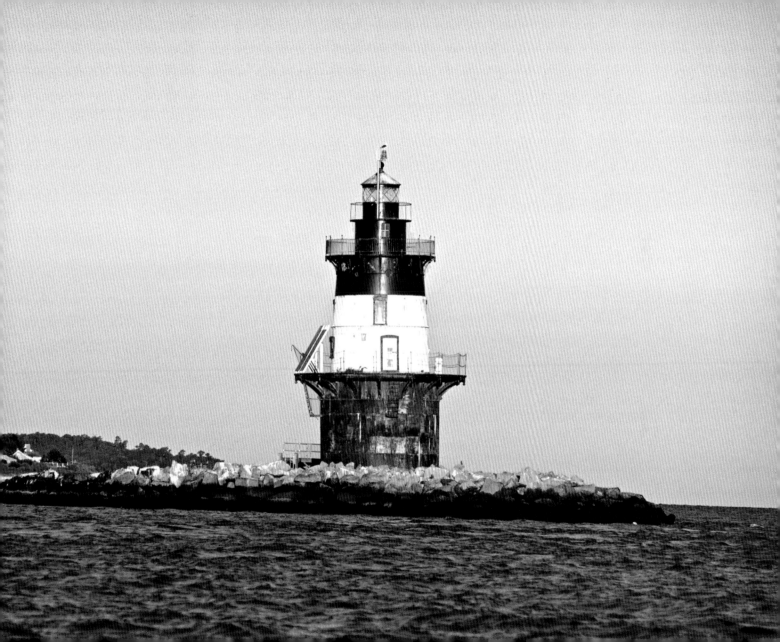

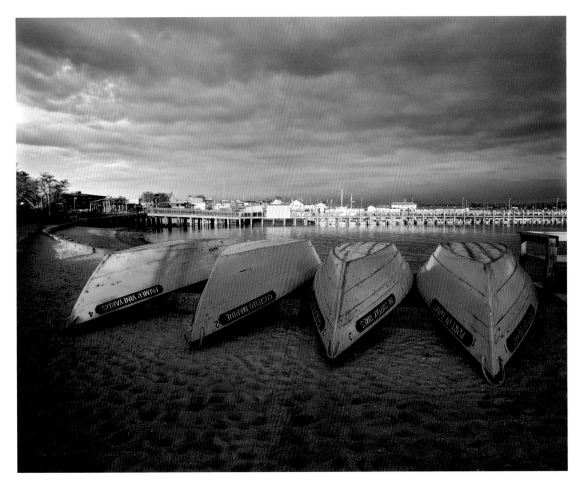

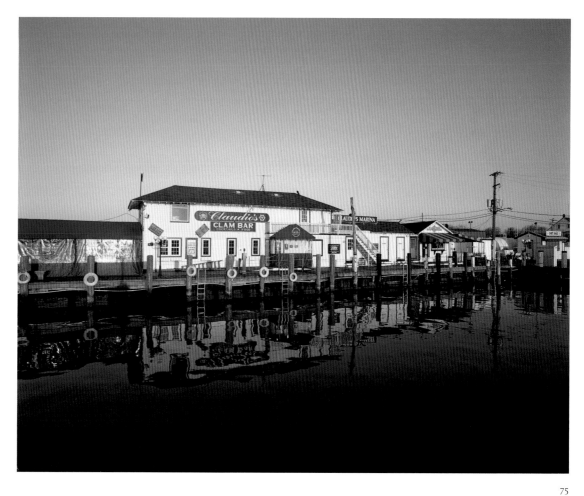

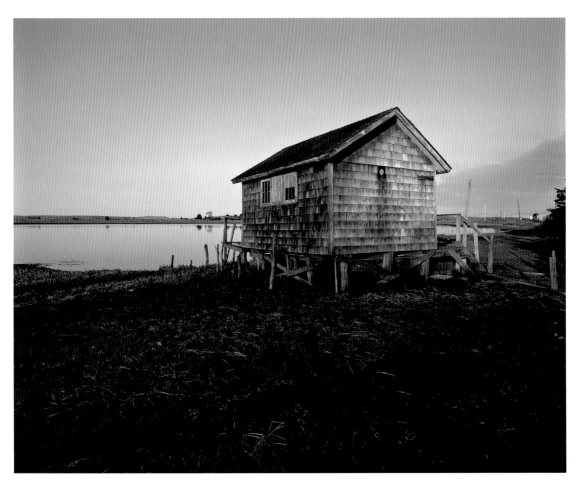

Clam Shack Orient
Dam Pond East Marion

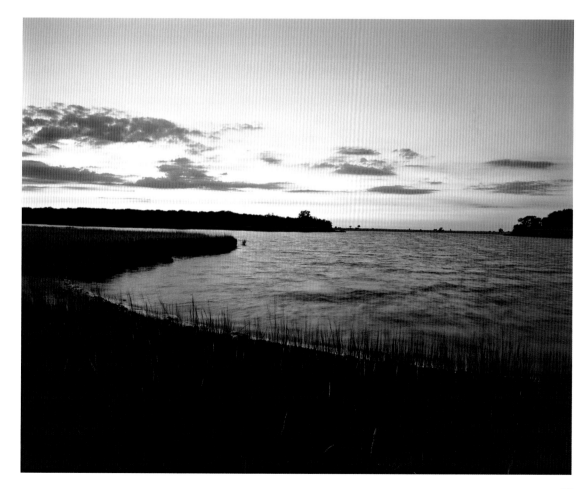

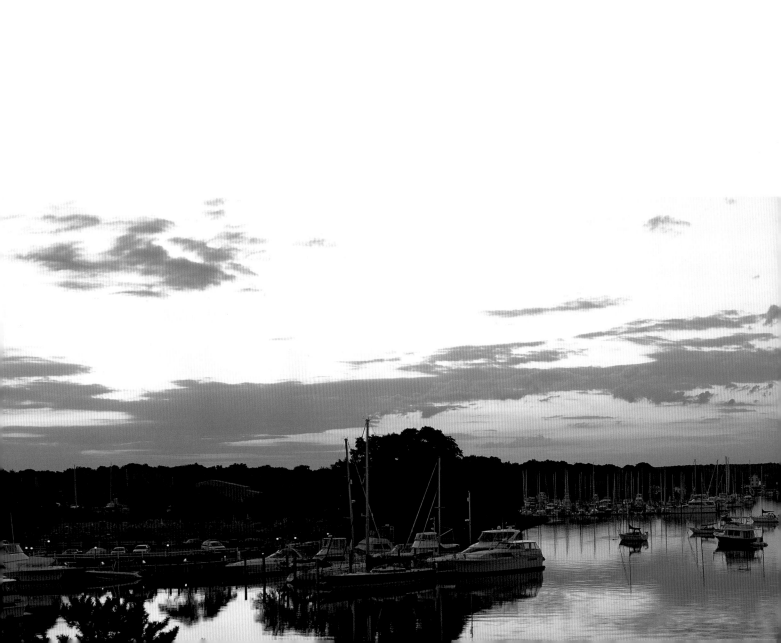

Sterling Harbor Greenport

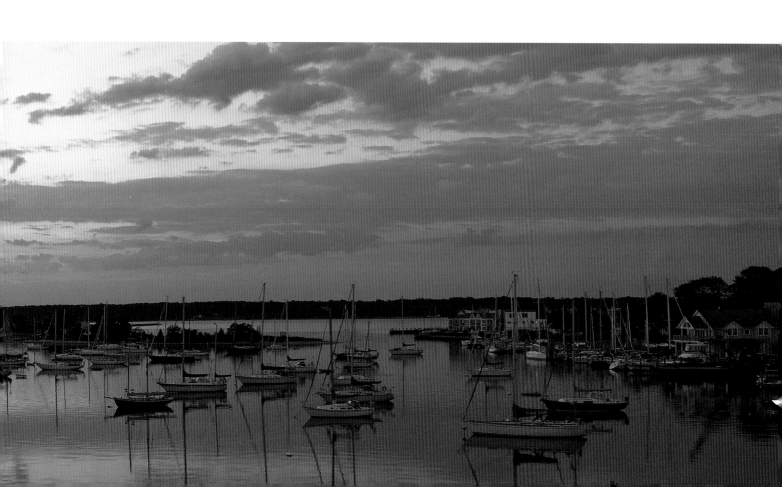

Sterling Harbor Greenport

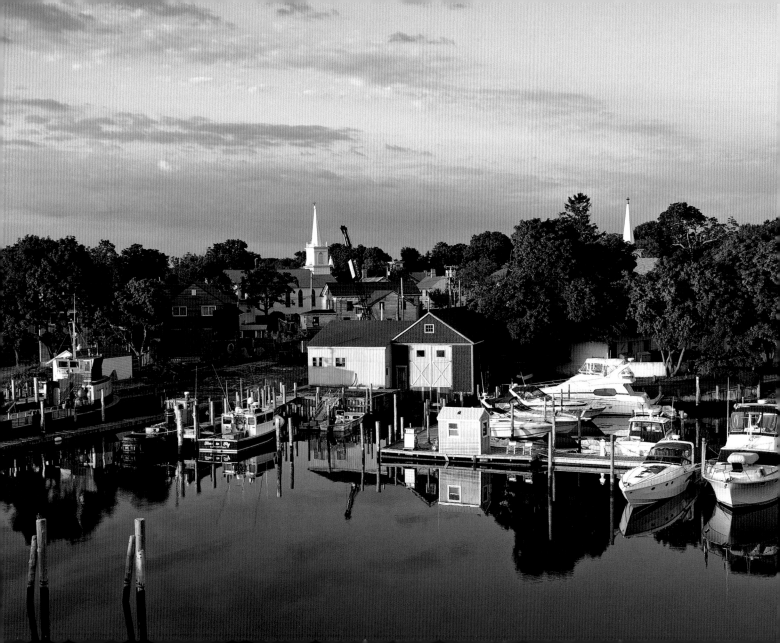

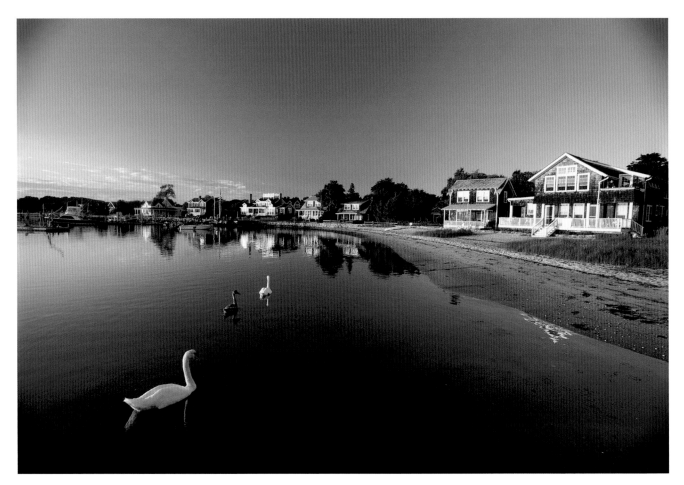

Orient
Greenport

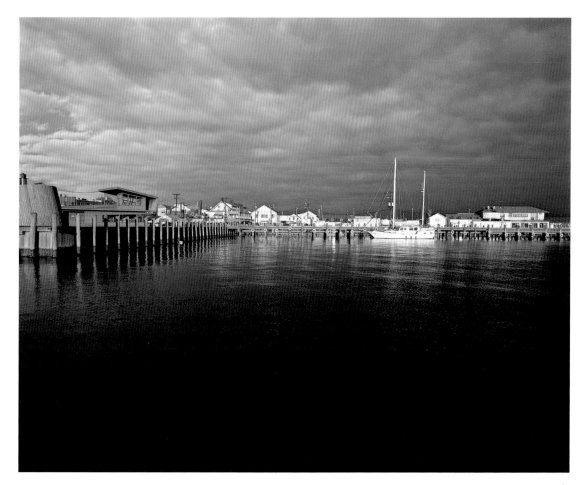

Barn Orient

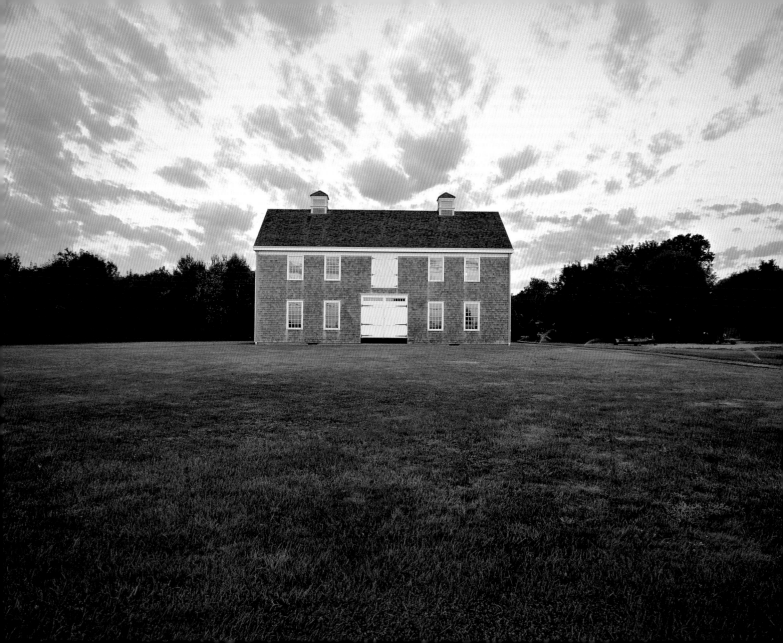

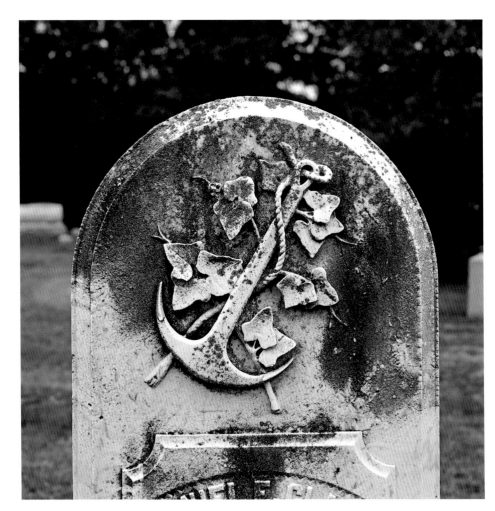

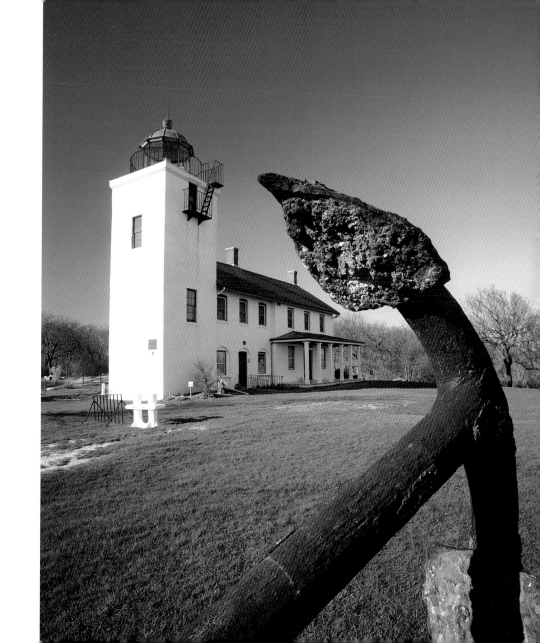

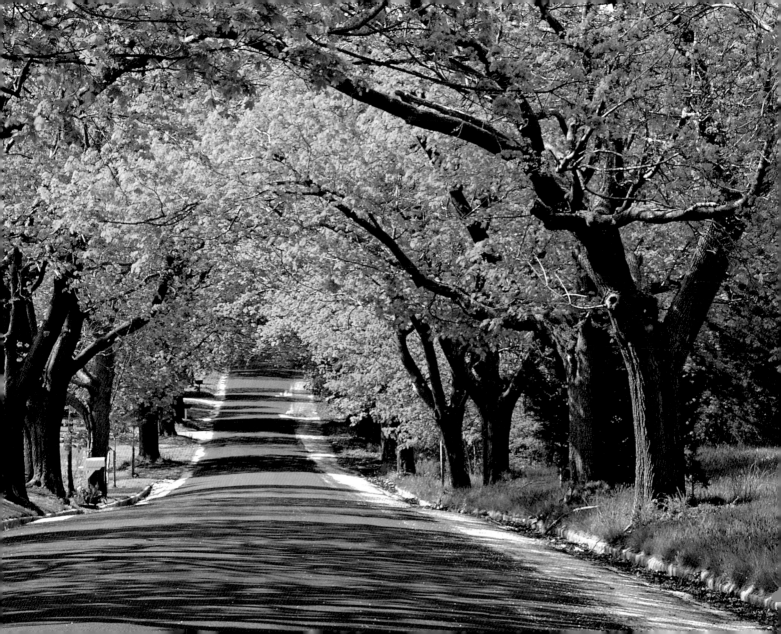

Greenport

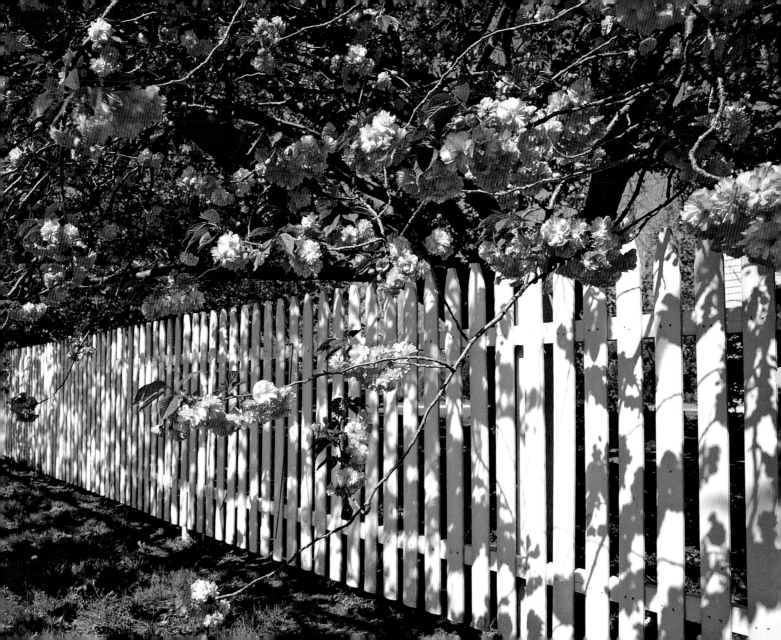

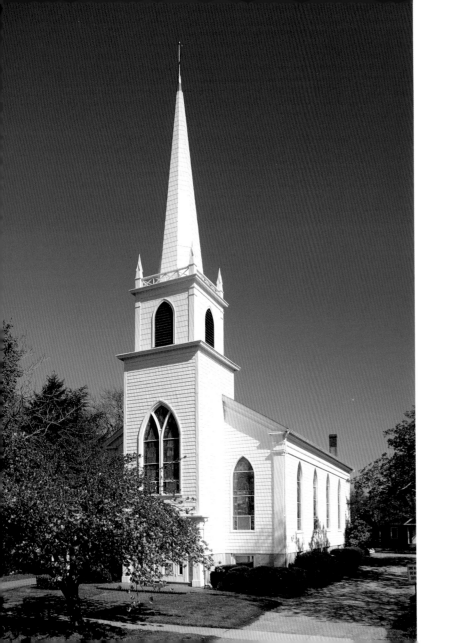

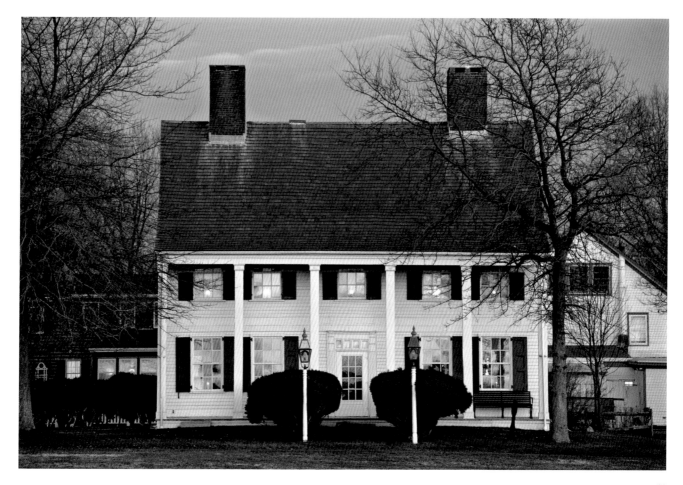

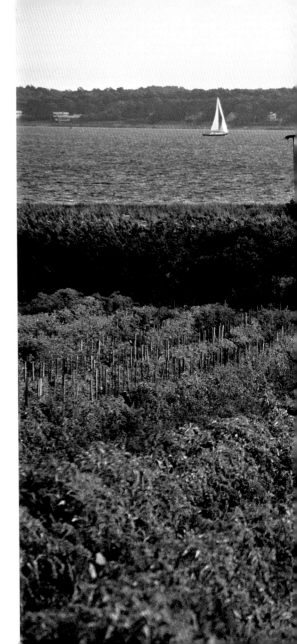

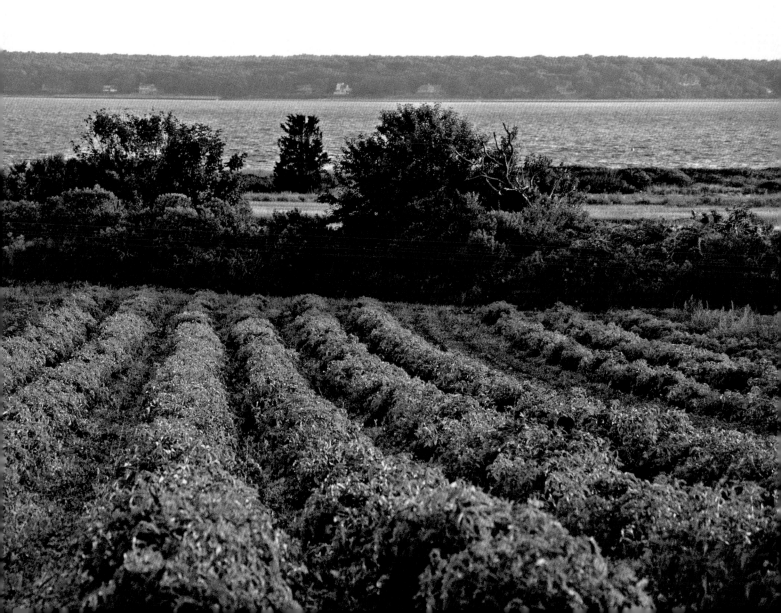

North Fork

Riverhead
Mattituck
Cutchogue
Peconic
Southold
Greenport
East Marion
Orient

Shelter Island

Shelter Island Heights
Dering Harbor

South Fork

Westhampton
Quogue
Hampton Bays
Shinnecock
Southampton
Water Mill
Bridgehampton
Sagaponack
Sag Harbor
Springs
East Hampton
Amagansett
Montauk

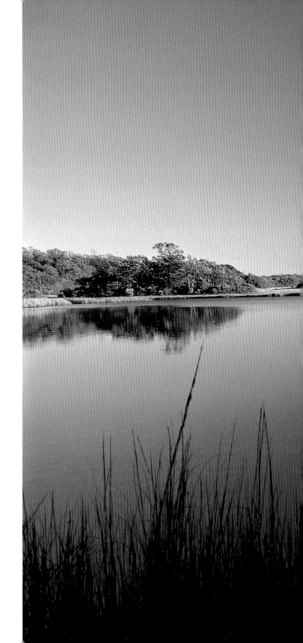

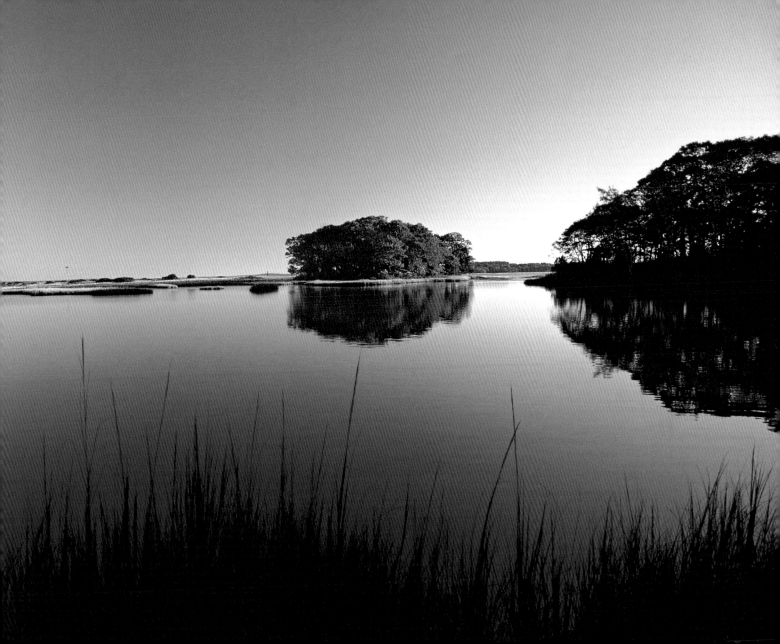

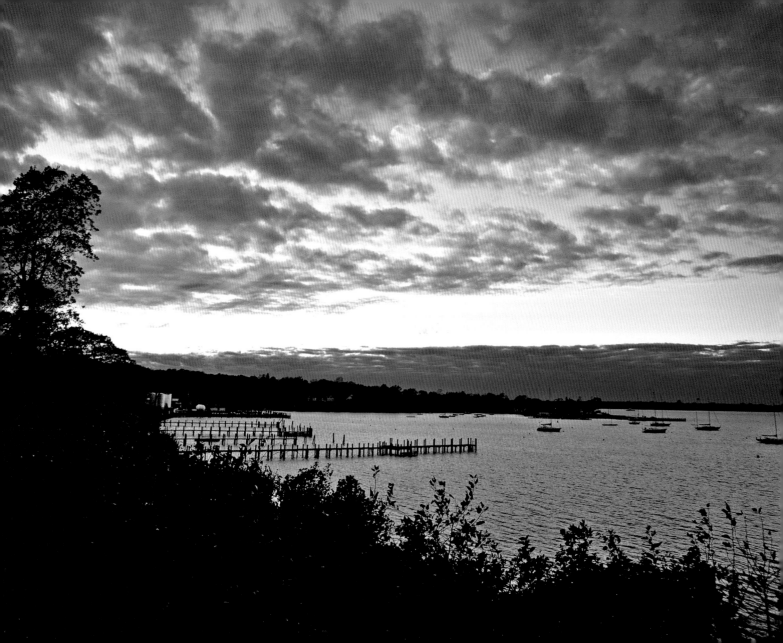

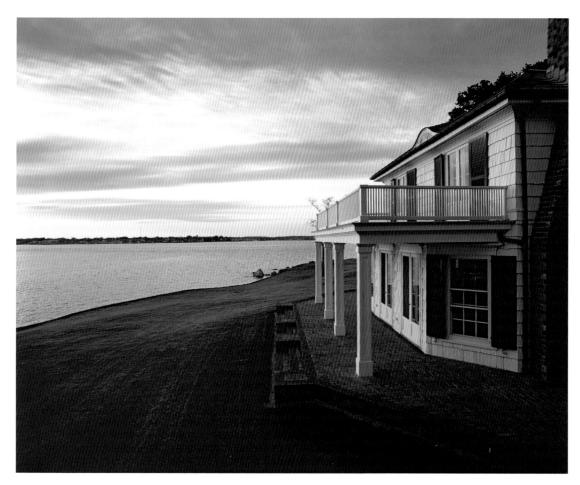

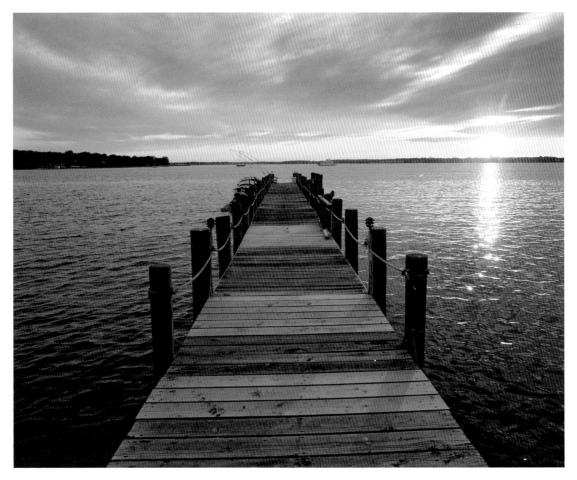

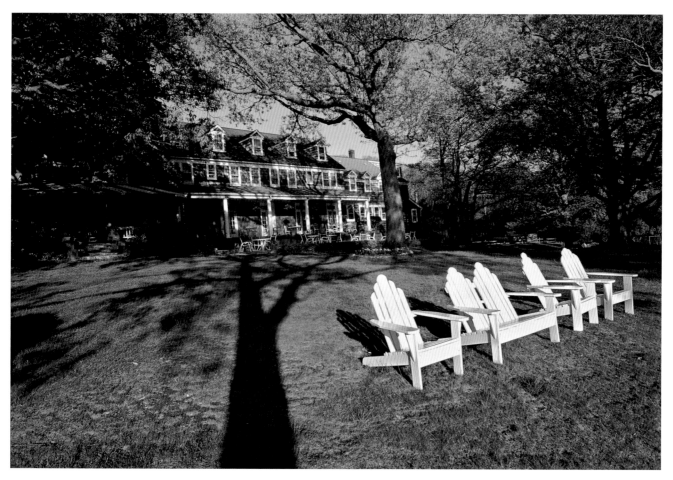

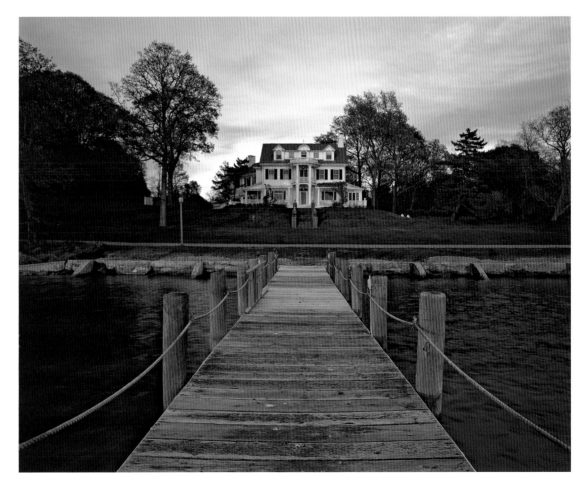

Shelter Island

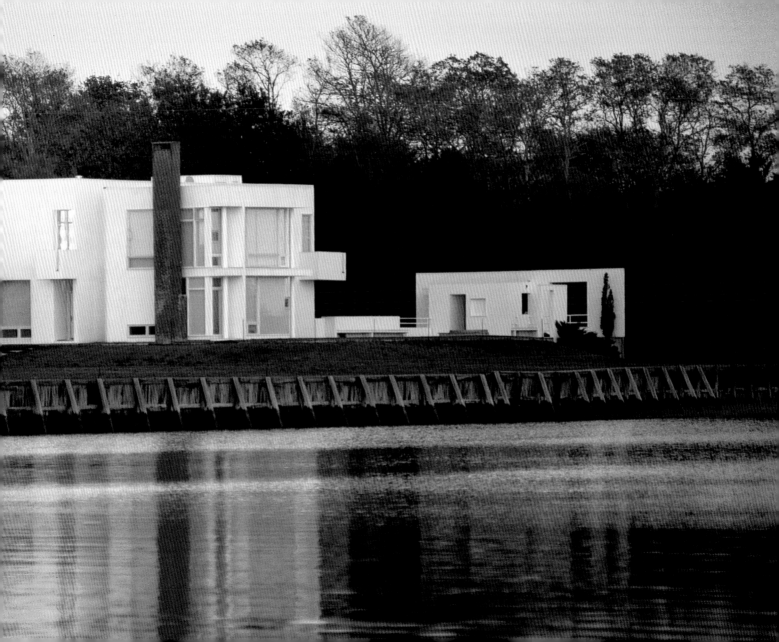

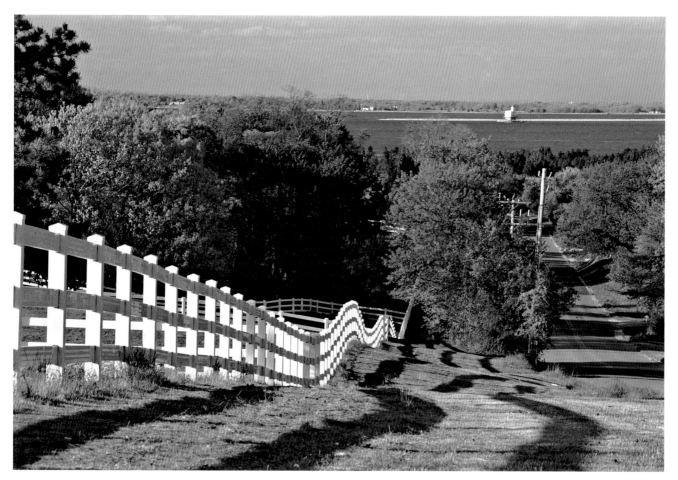

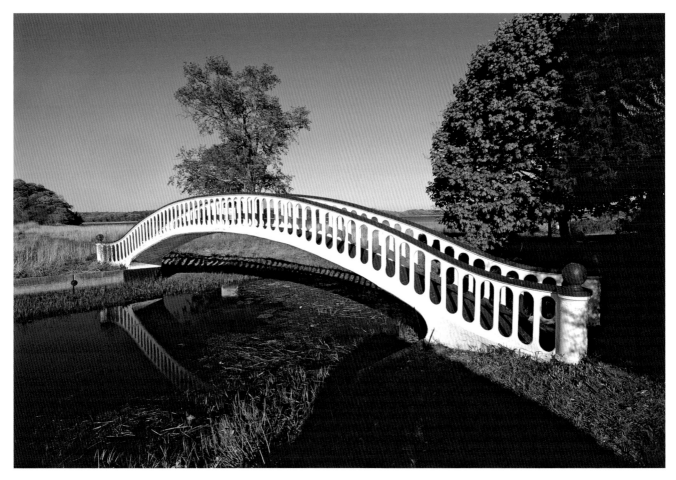

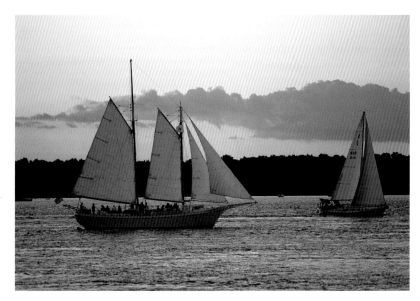

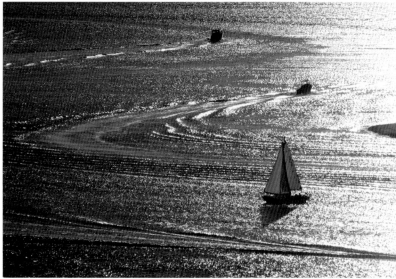

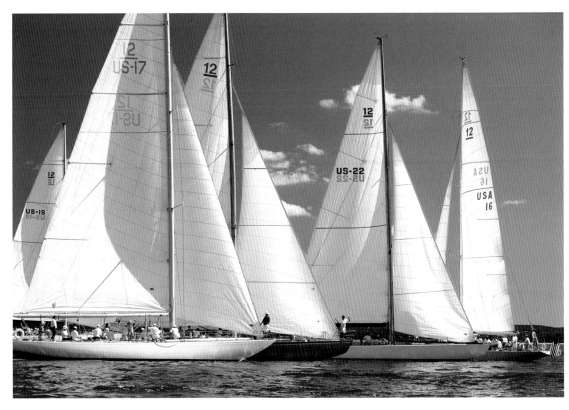

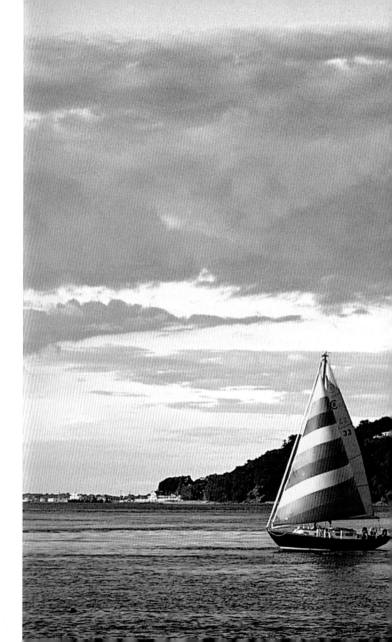

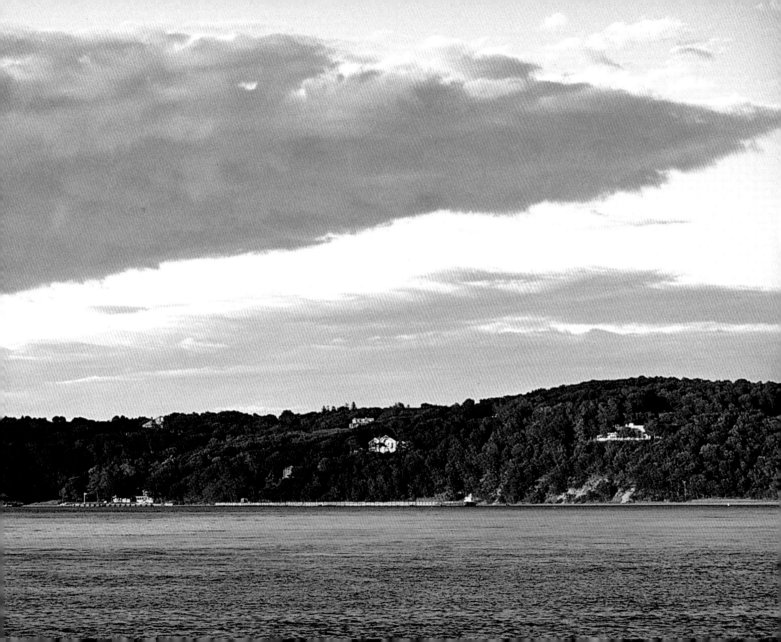

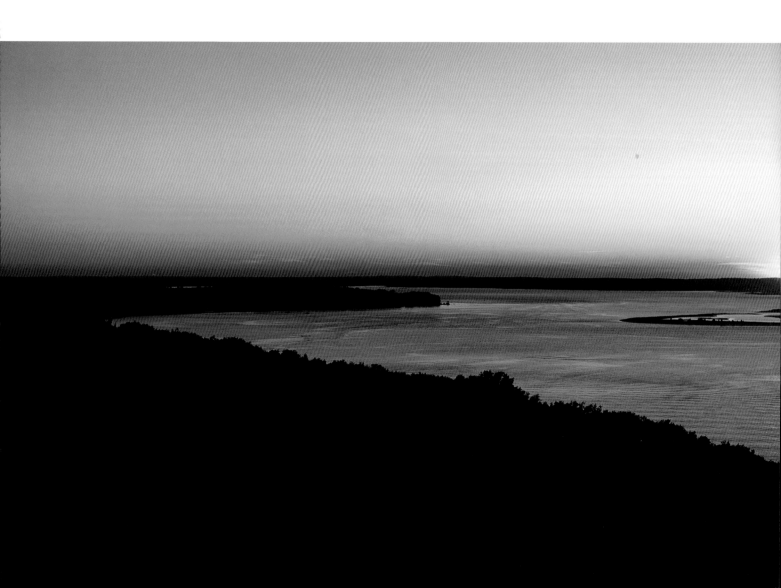

North Fork	Shelter Island	South Fork
Riverhead	Shelter Island Heights	Westhampton
Mattituck	Dering Harbor	Quogue
Cutchogue		Hampton Bays
Peconic		Shinnecock
Southold		Southampton
Greenport		Water Mill
East Marion		Bridgehampton
Orient		Sagaponack
		Sag Harbor
		Springs
		East Hampton
		Amagansett
		Montauk

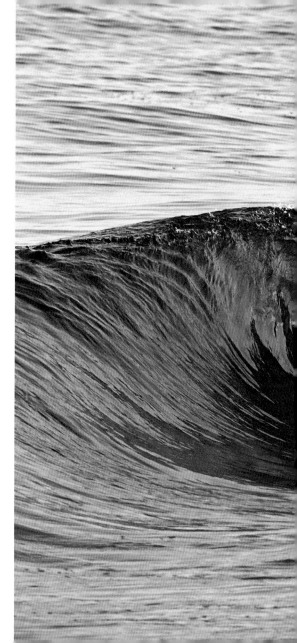

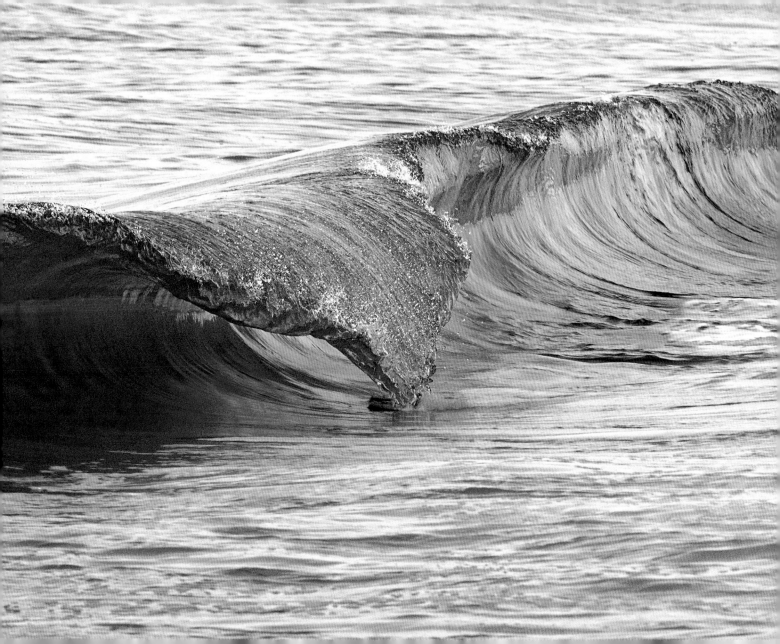

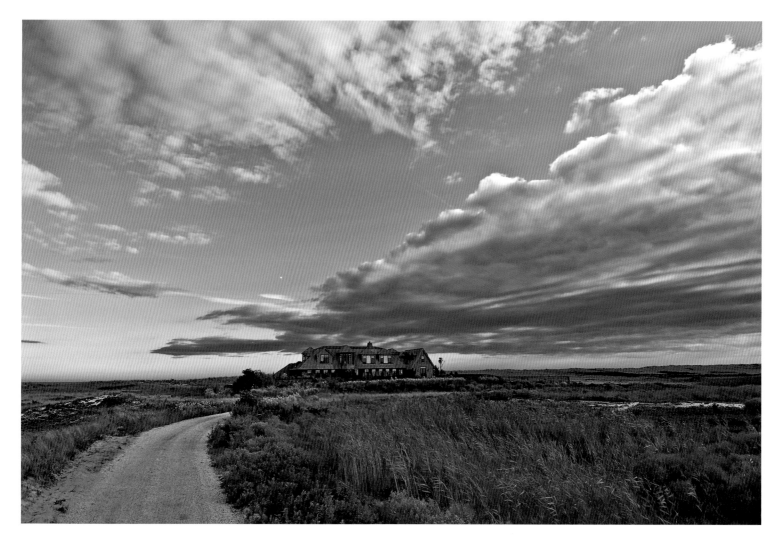

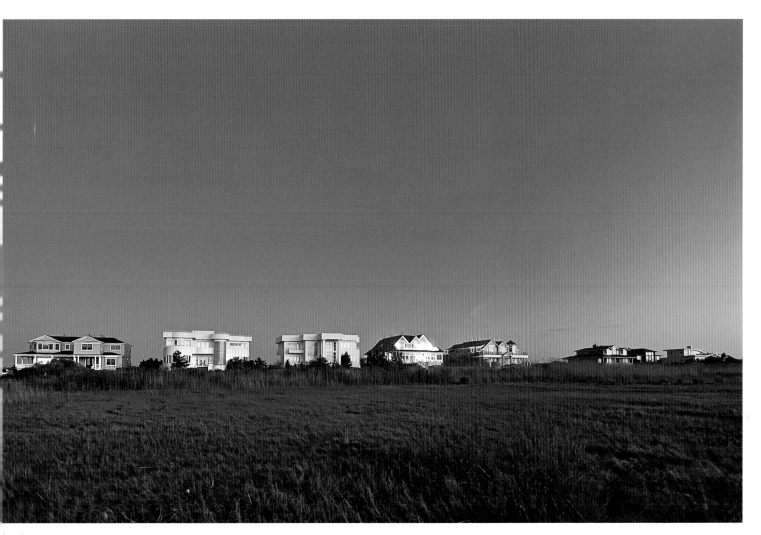

Quogue

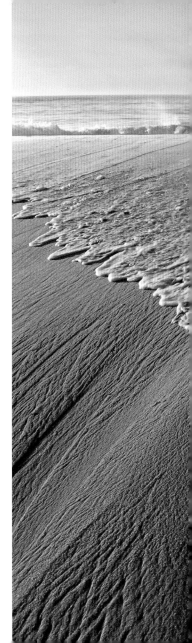

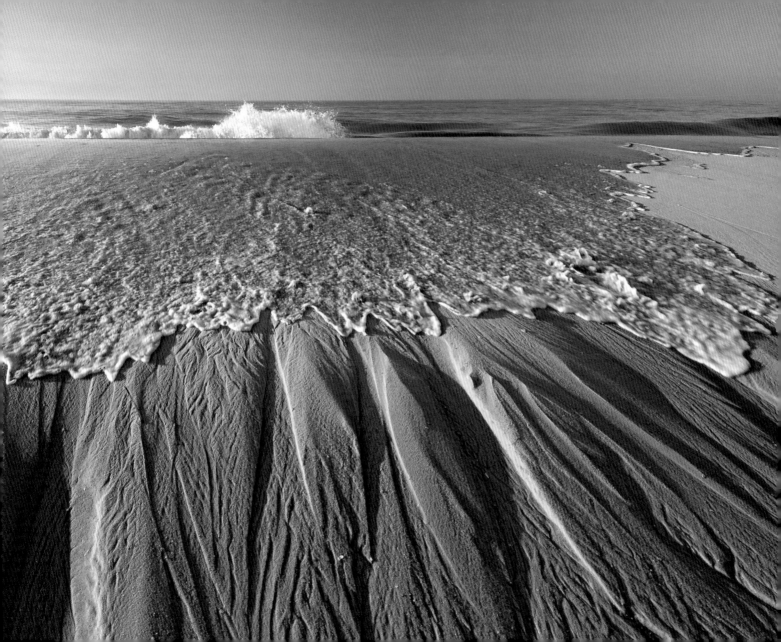

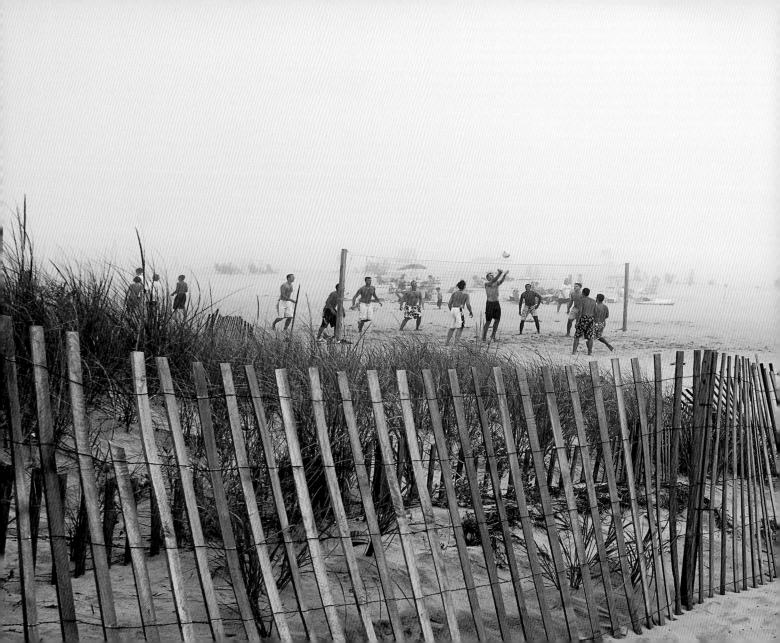

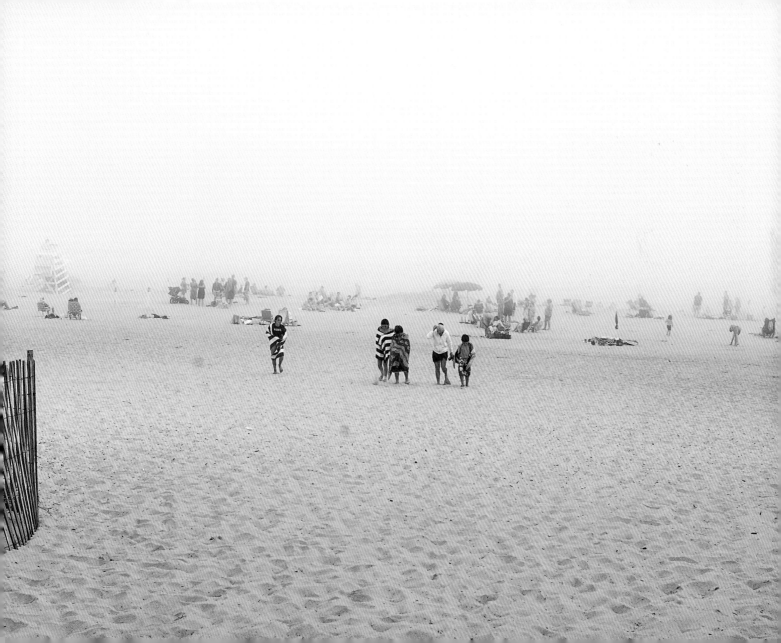

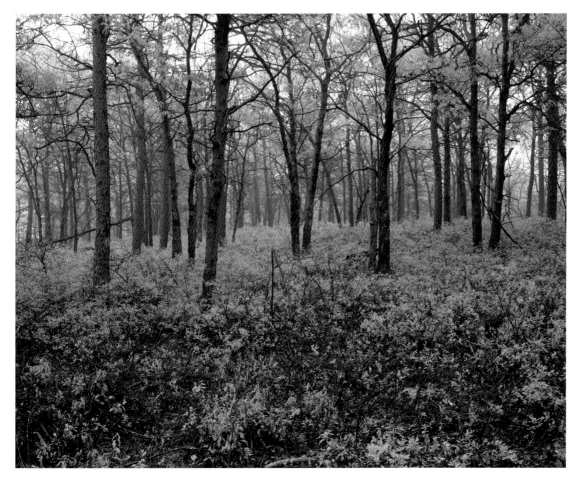

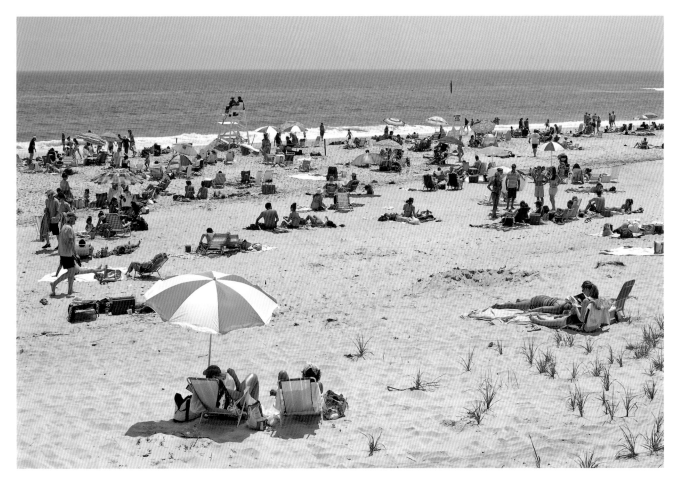

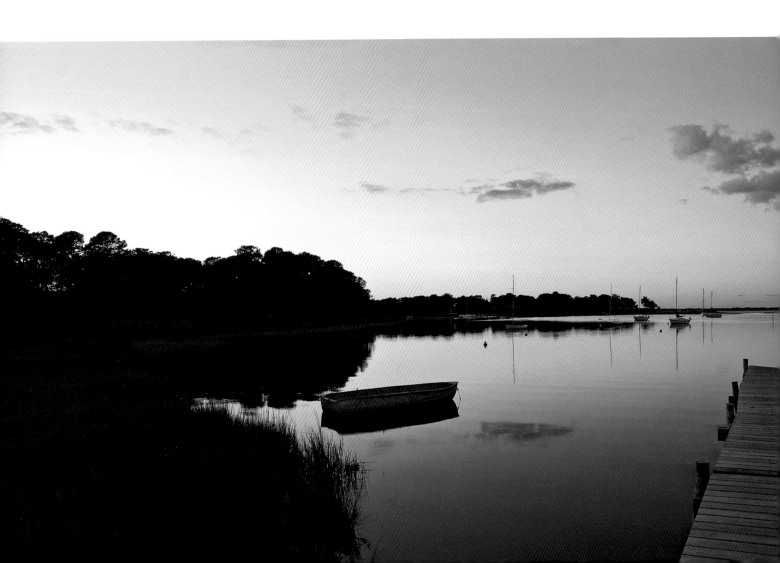

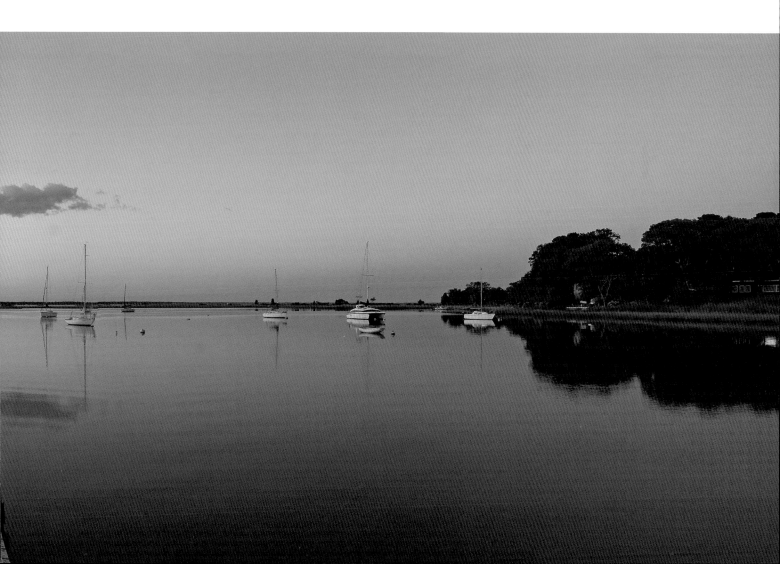

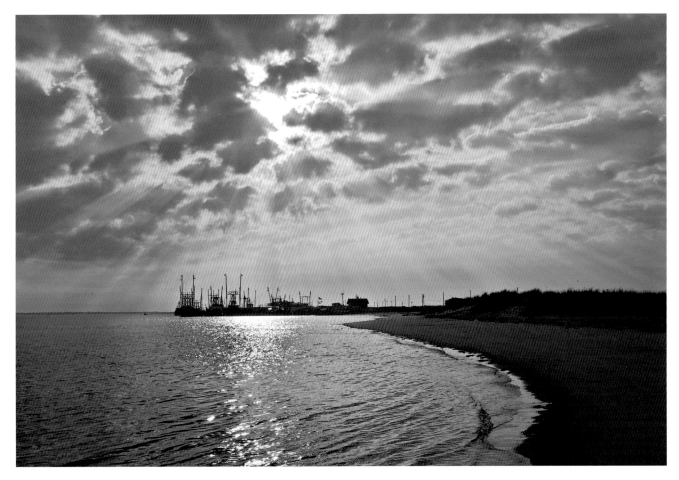

Tiana Shores Hampton Bays
Moriches Bay Westhampton

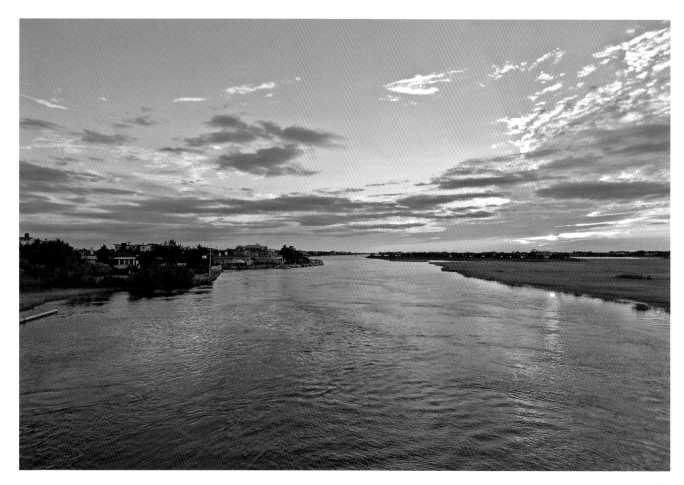

Quogue

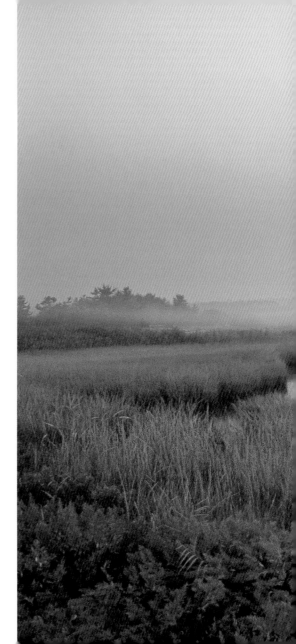

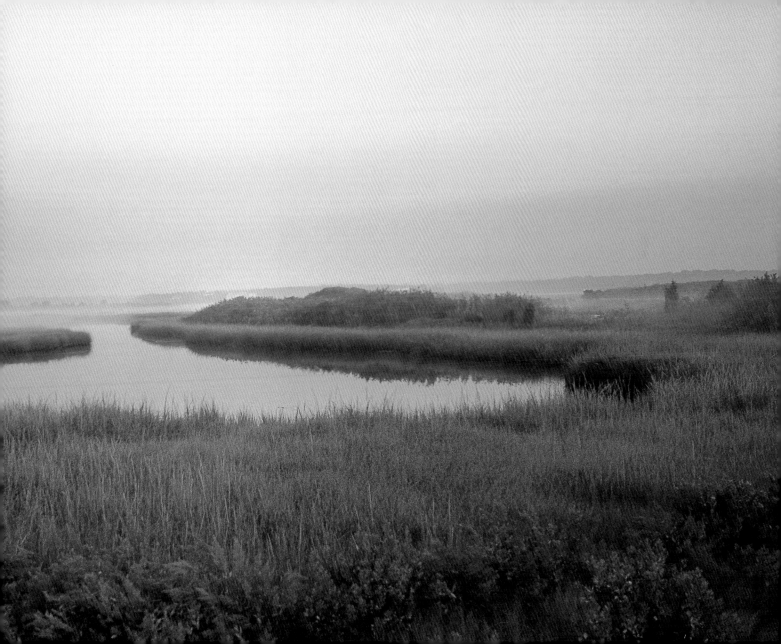

North Fork

Riverhead
Mattituck
Cutchogue
Peconic
Southold
Greenport
East Marion
Orient

Shelter Island

Shelter Island Heights
Dering Harbor

South Fork

Westhampton
Quogue
Hampton Bays
Shinnecock
Southampton
Water Mill
Bridgehampton
Sagaponack
Sag Harbor
Springs
East Hampton
Amagansett
Montauk

Shinnecock Bay

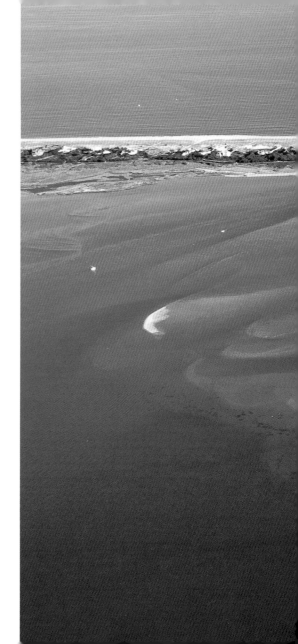

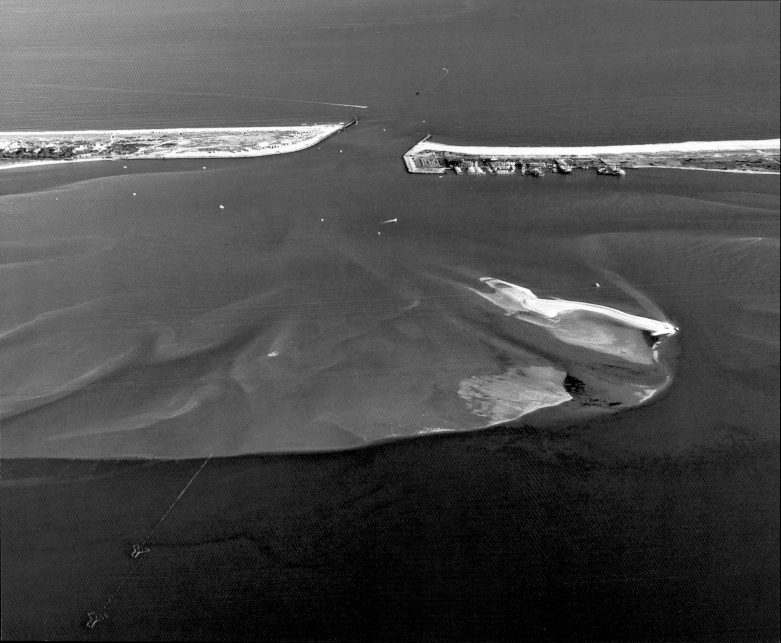

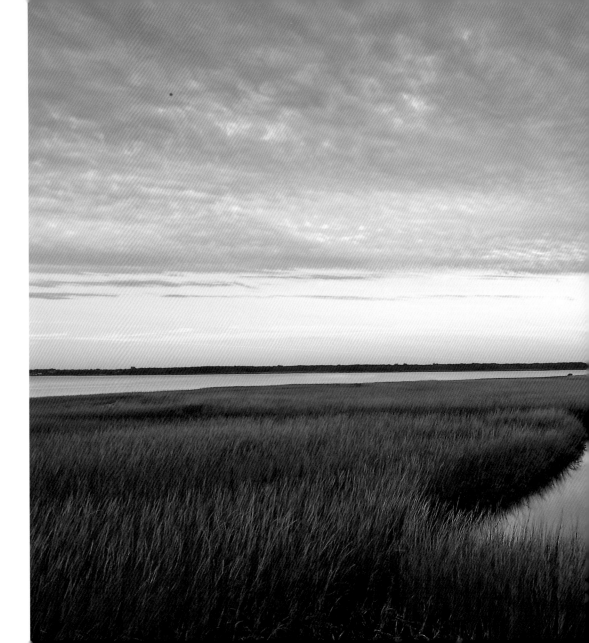

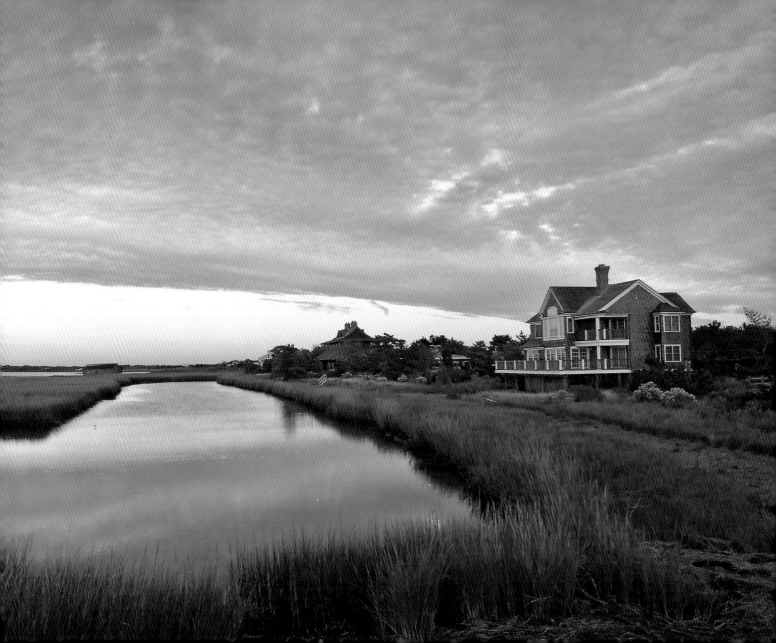

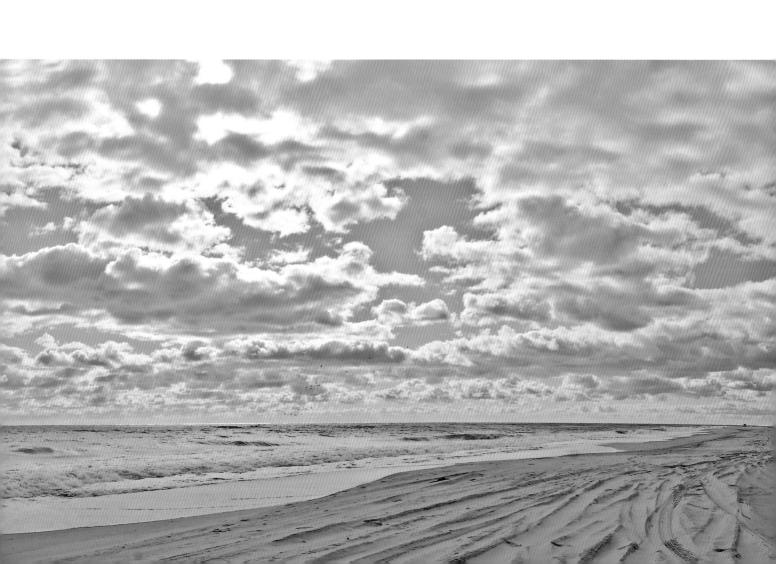

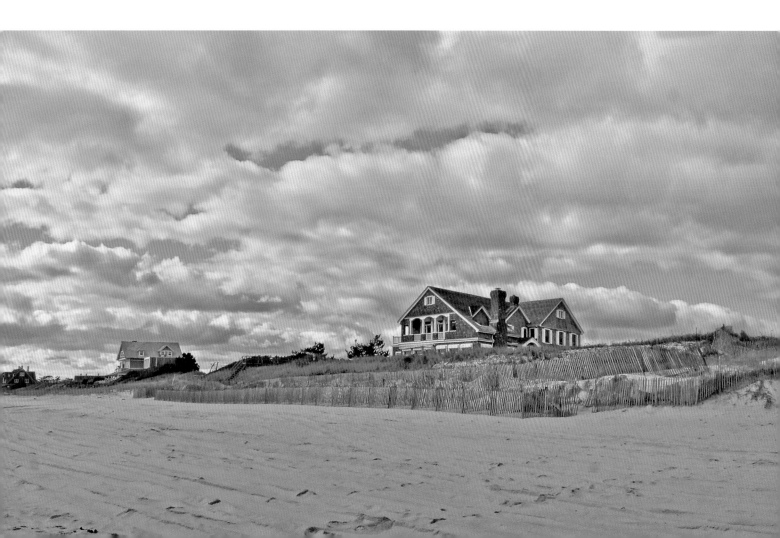

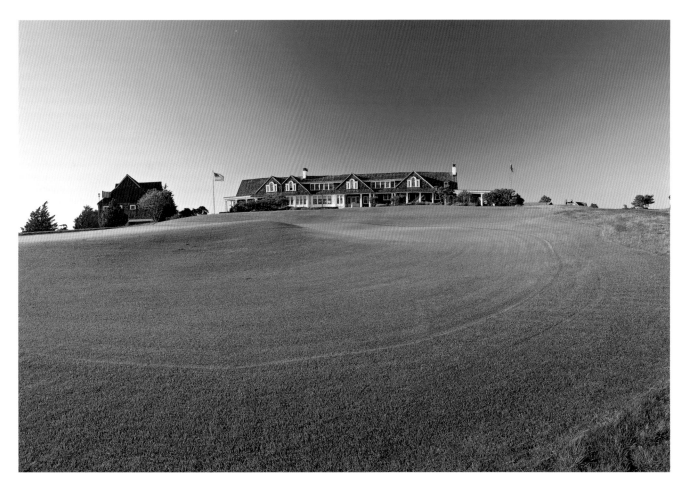

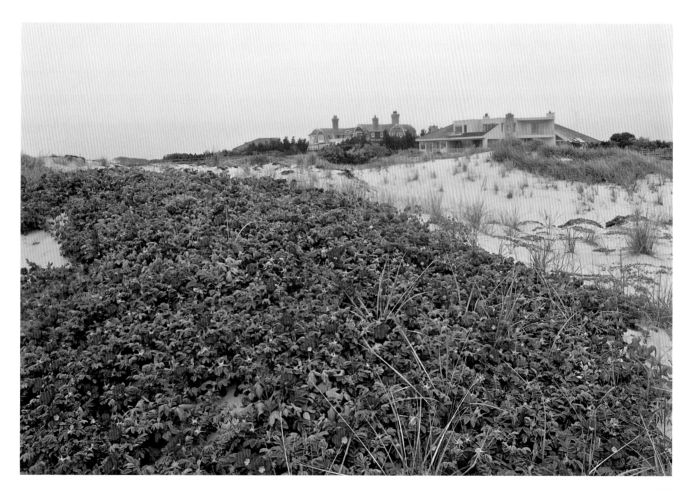

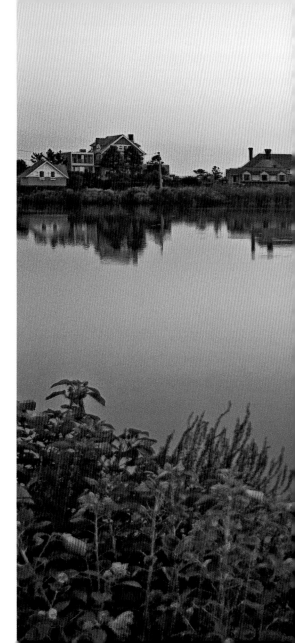

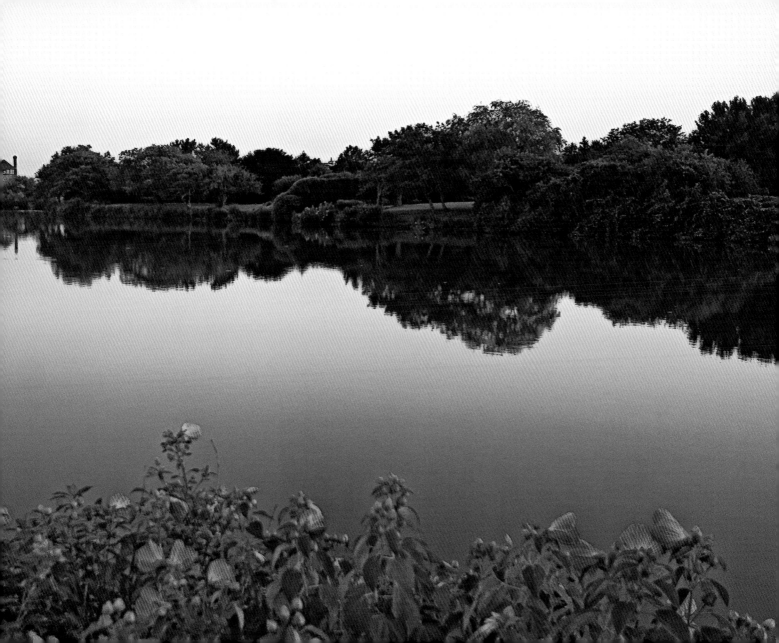

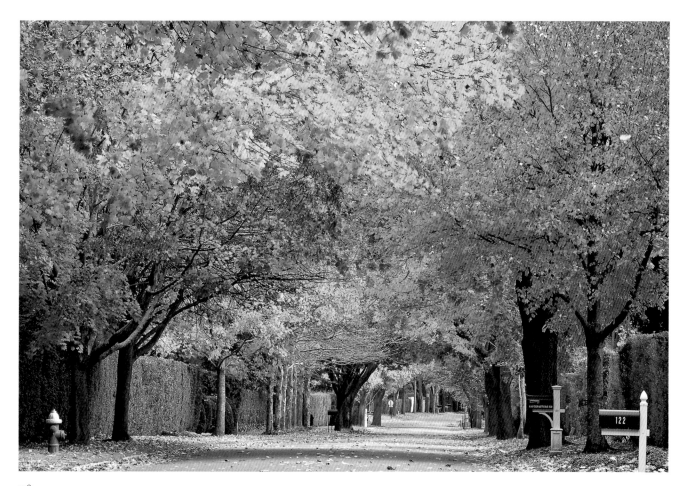

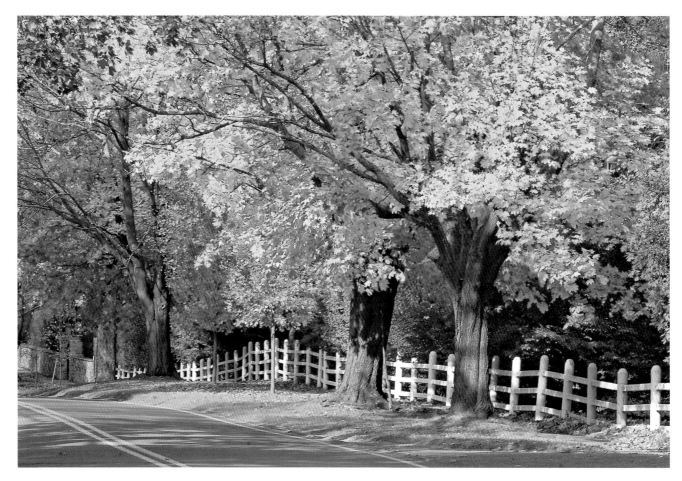

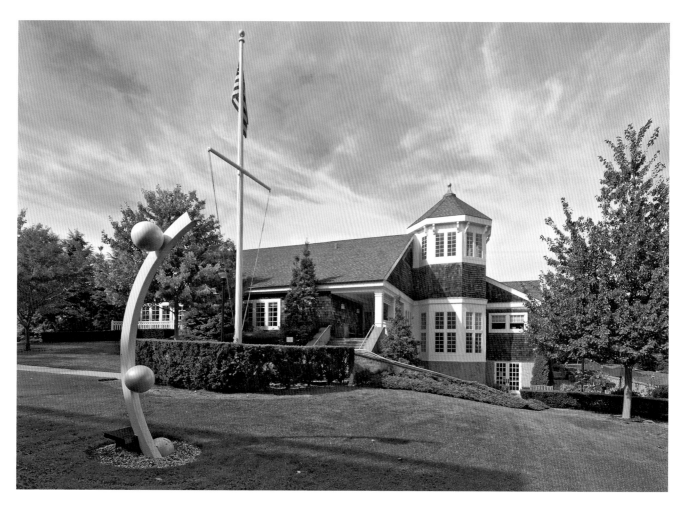

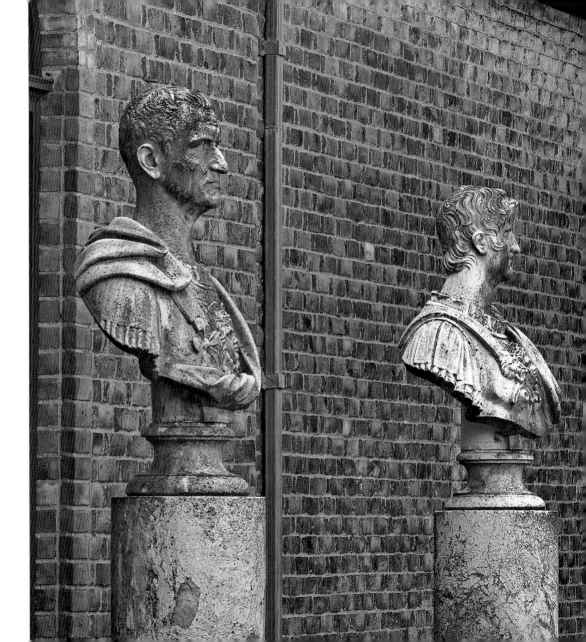

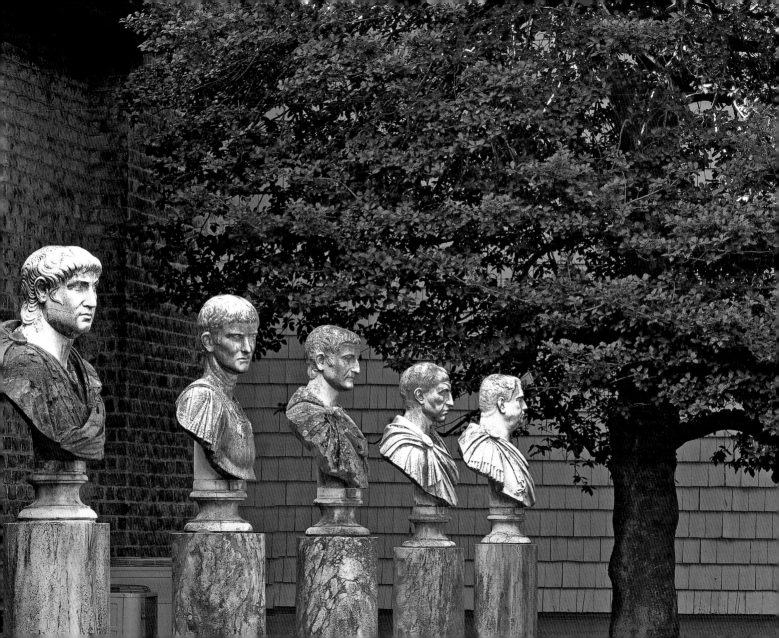

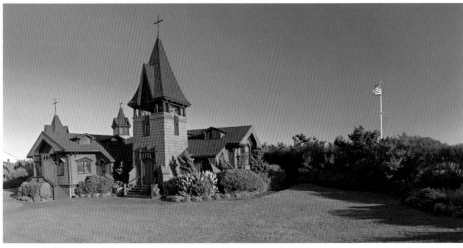

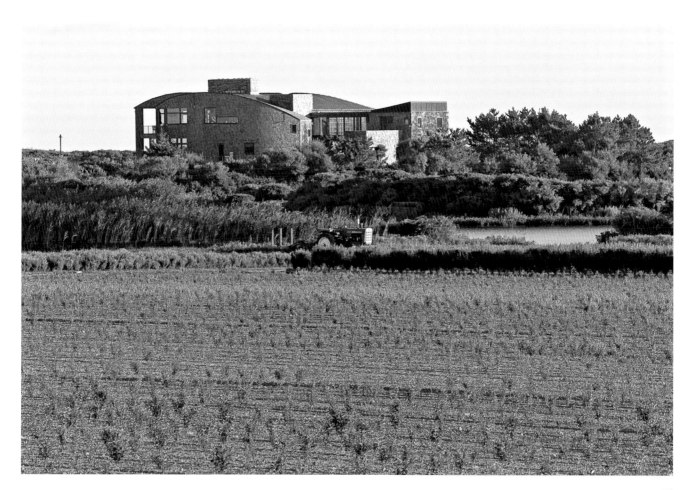

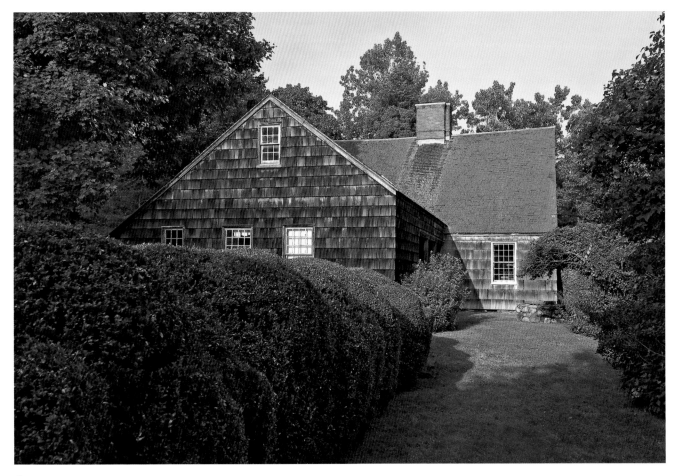

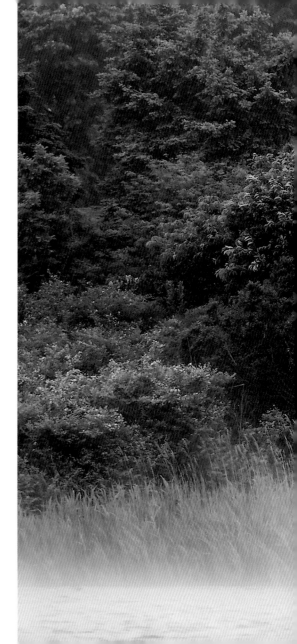

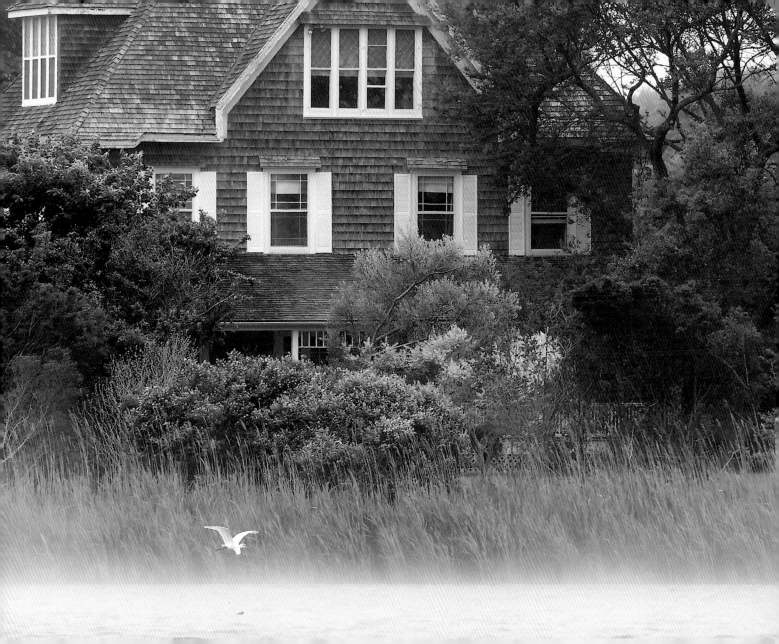

North Fork	Shelter Island	South Fork
Riverhead	Shelter Island Heights	Westhampton
Mattituck	Dering Harbor	Quogue
Cutchogue		Hampton Bays
Peconic		Shinnecock
Southold		Southampton
Greenport		**Water Mill**
East Marion		**Bridgehampton**
Orient		**Sagaponack**
		Sag Harbor
		Springs
		East Hampton
		Amagansett
		Montauk

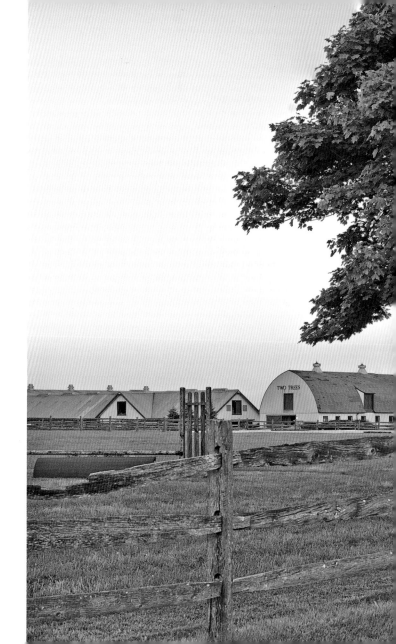

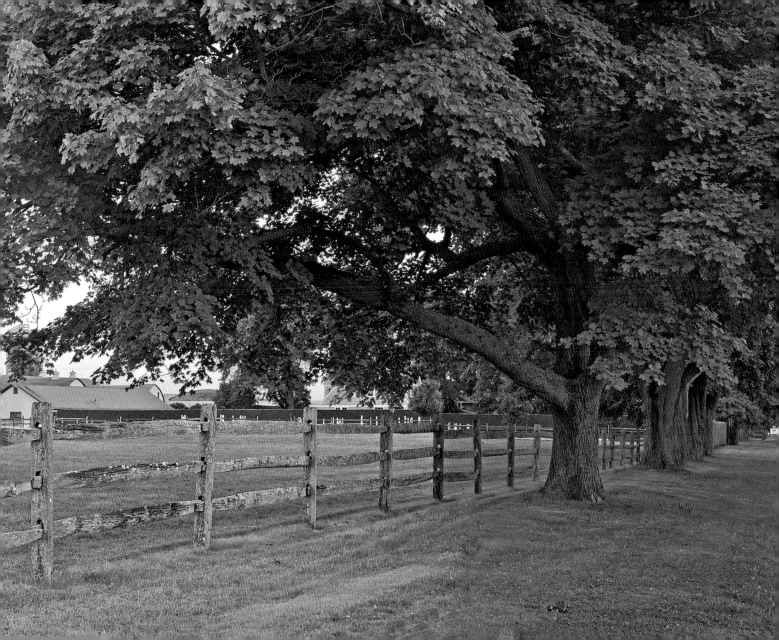

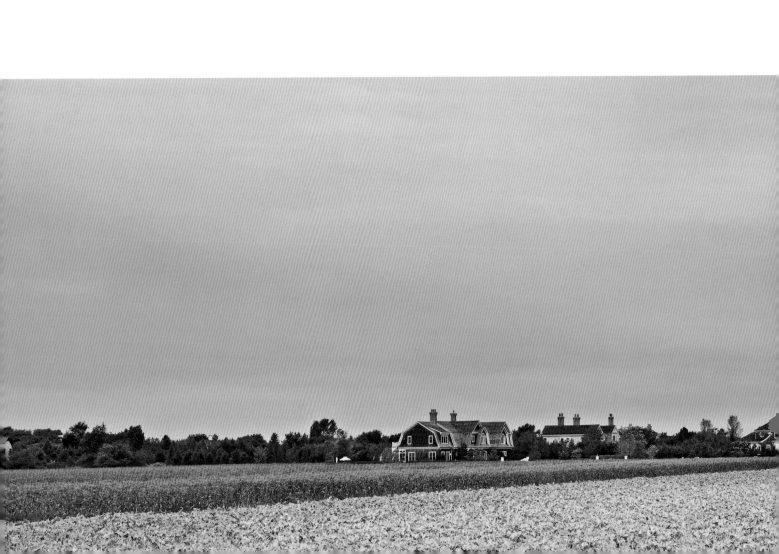

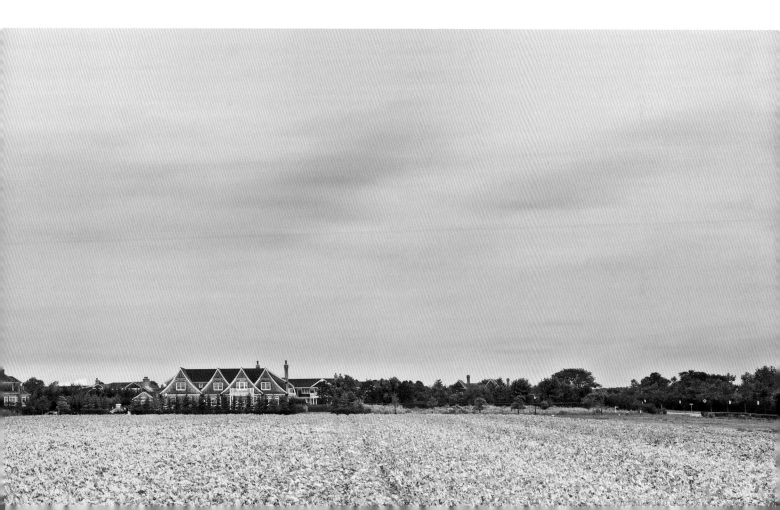

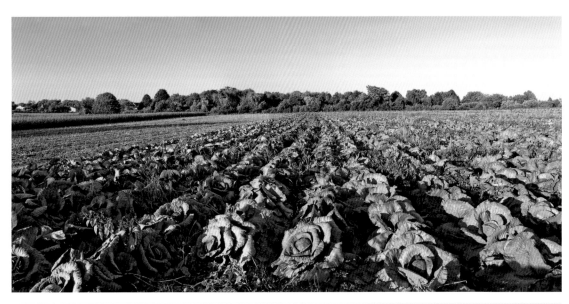

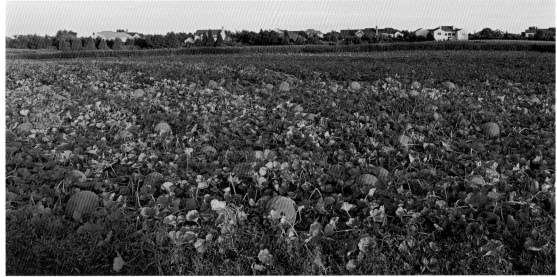

Watermill
Mecox
Channning Daughters Winery Bridgehampton

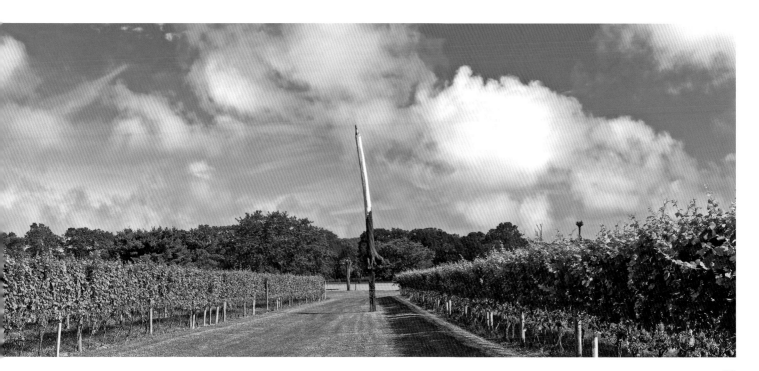

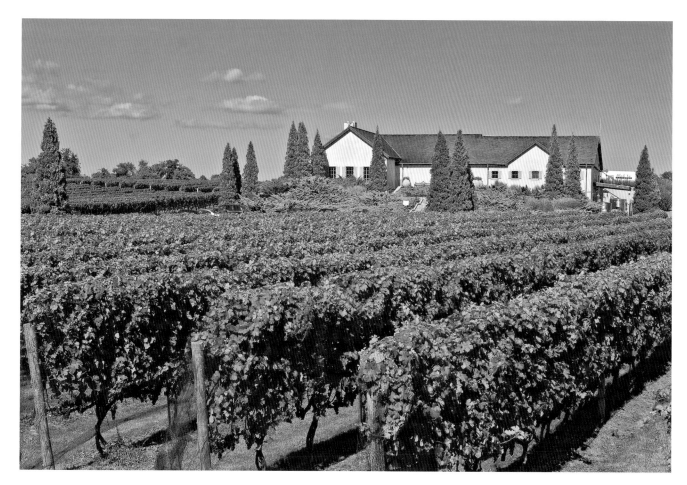

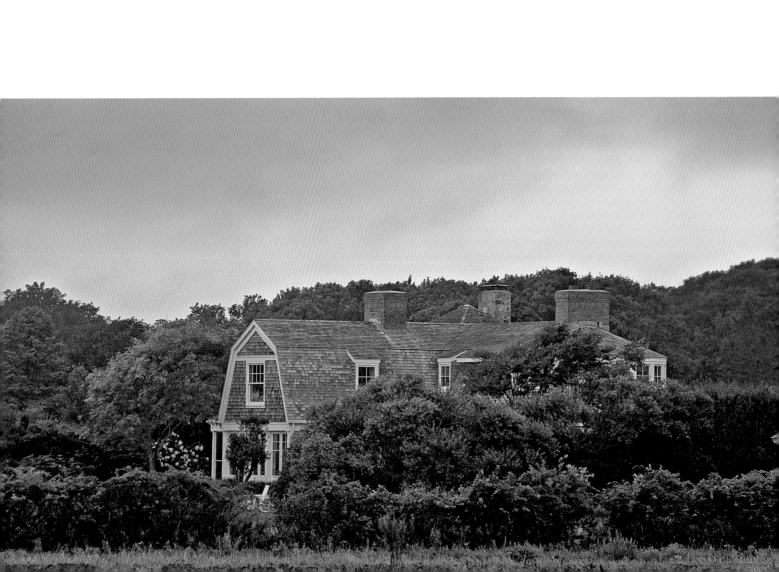

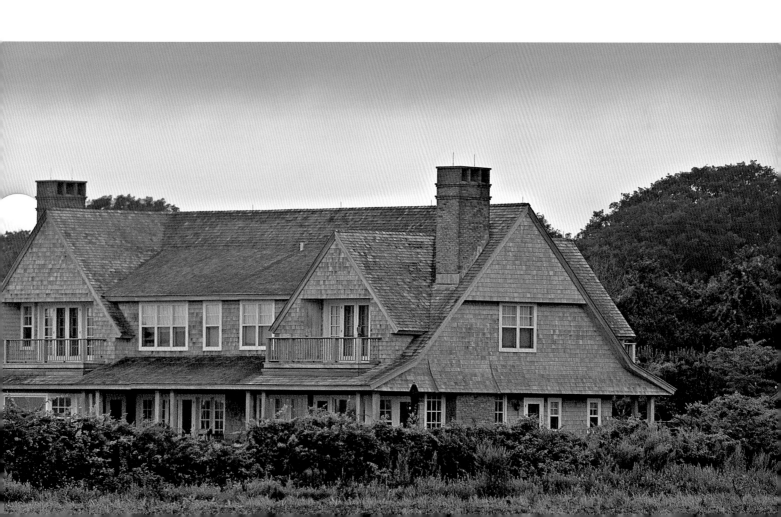

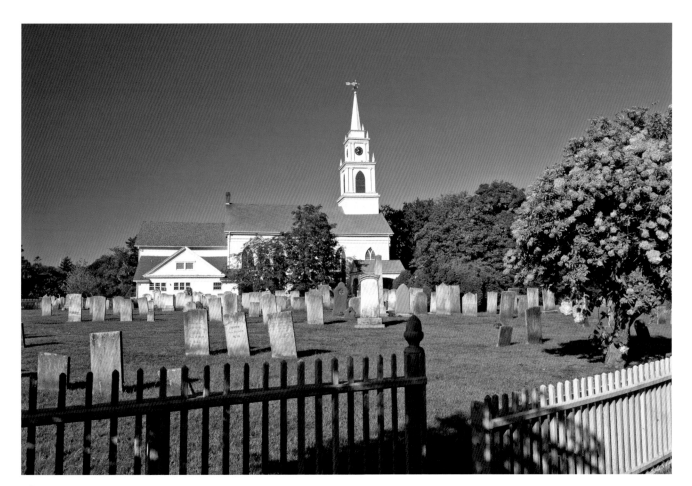

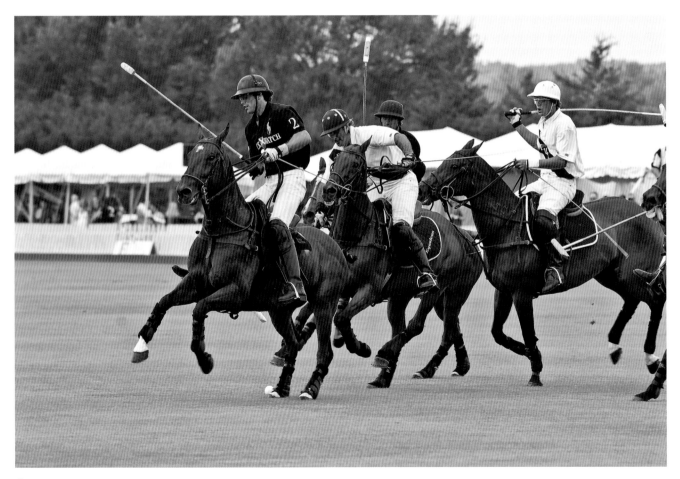

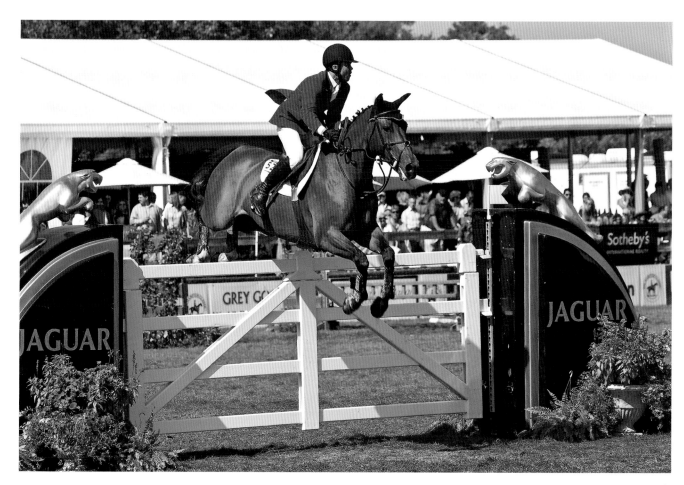

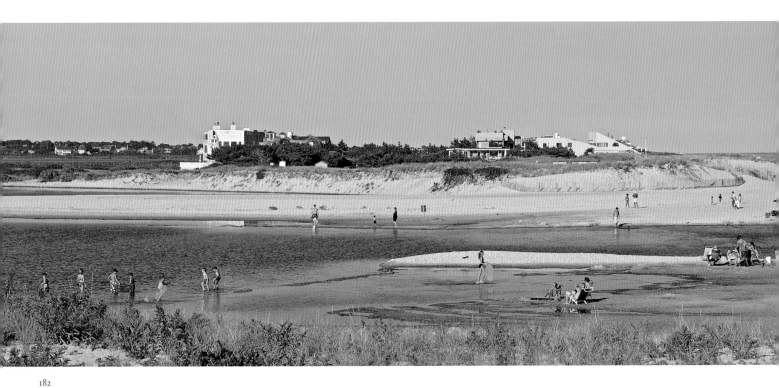

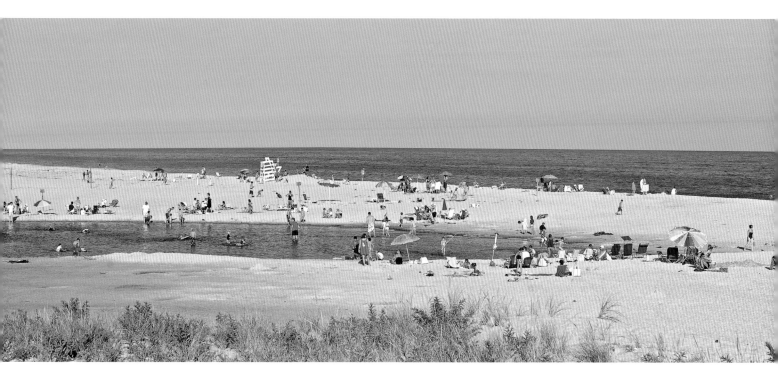

North Fork

Riverhead
Mattituck
Cutchogue
Peconic
Southold
Greenport
East Marion
Orient

Shelter Island

Shelter Island Heights
Dering Harbor

South Fork

Westhampton
Quogue
Hampton Bays
Shinnecock
Southampton
Water Mill
Bridgehampton
Sagaponack
Sag Harbor
Springs
East Hampton
Amagansett
Montauk

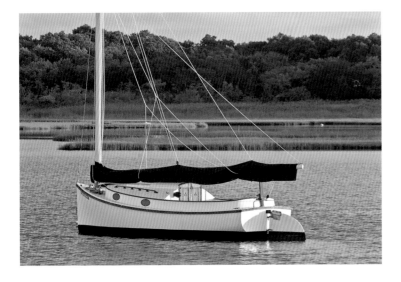

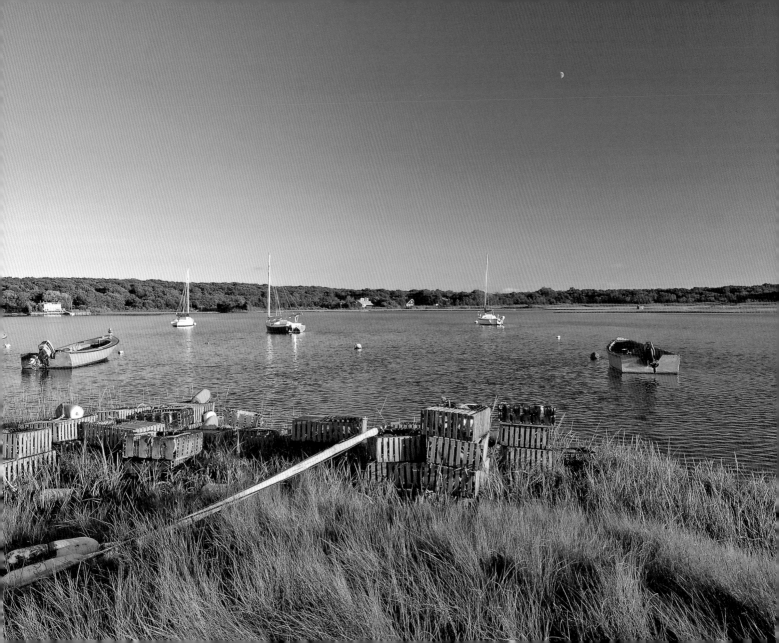

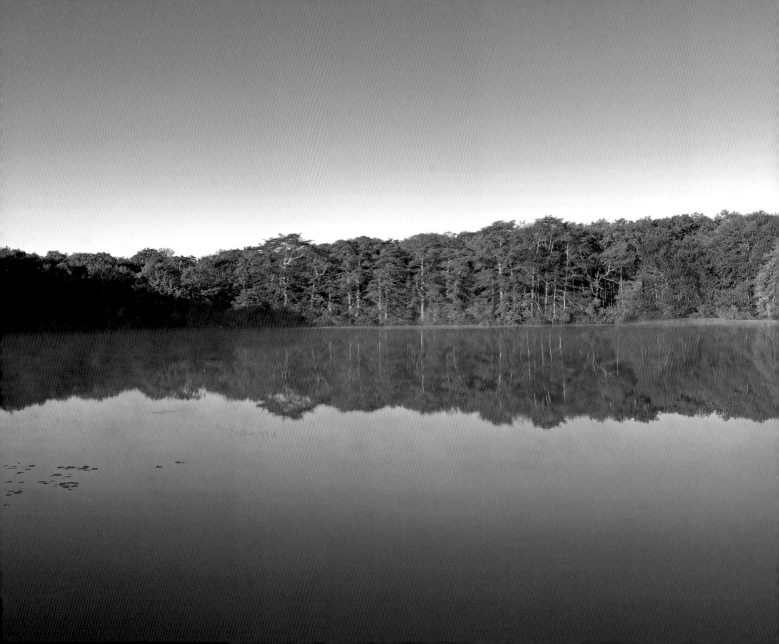

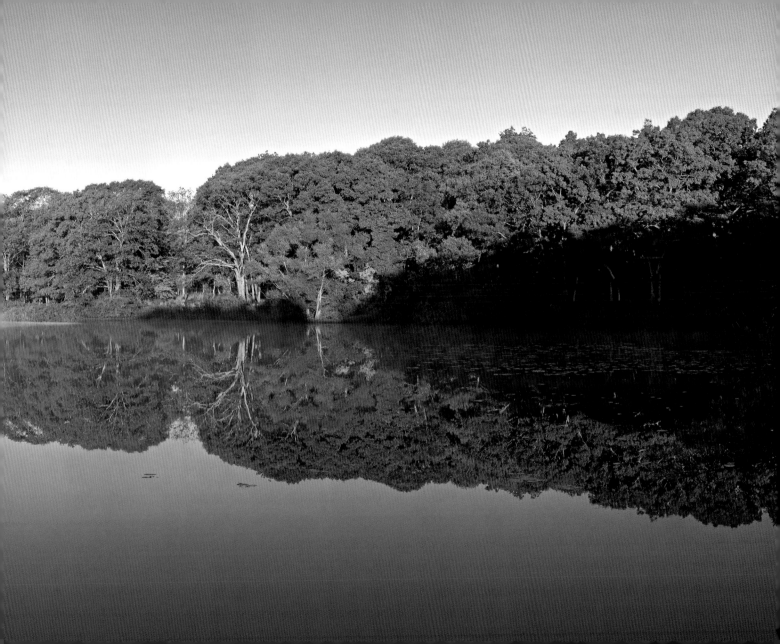

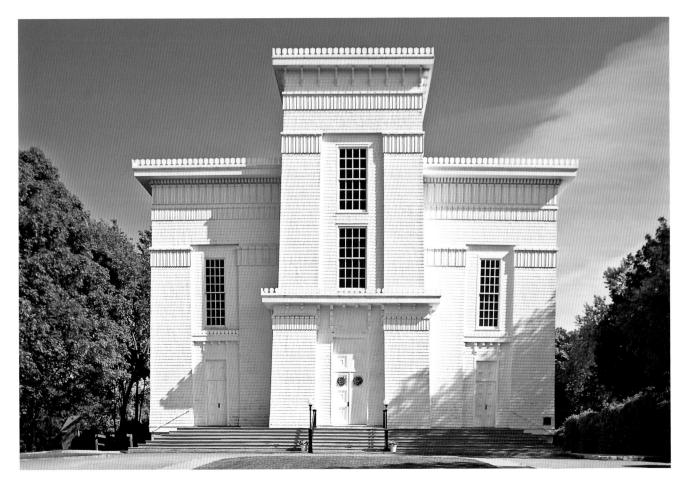

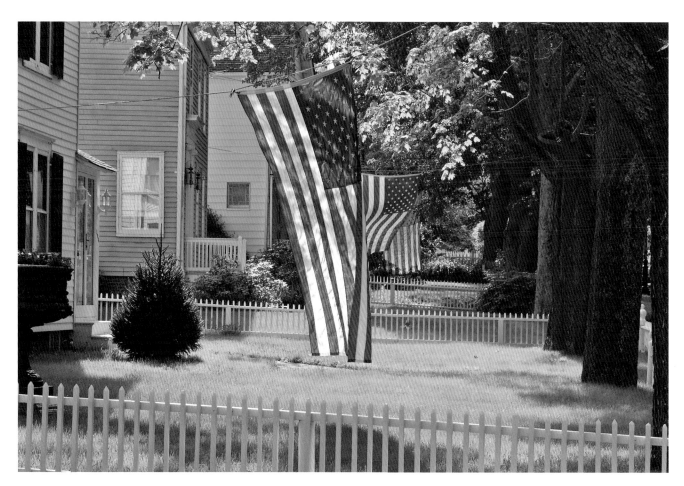

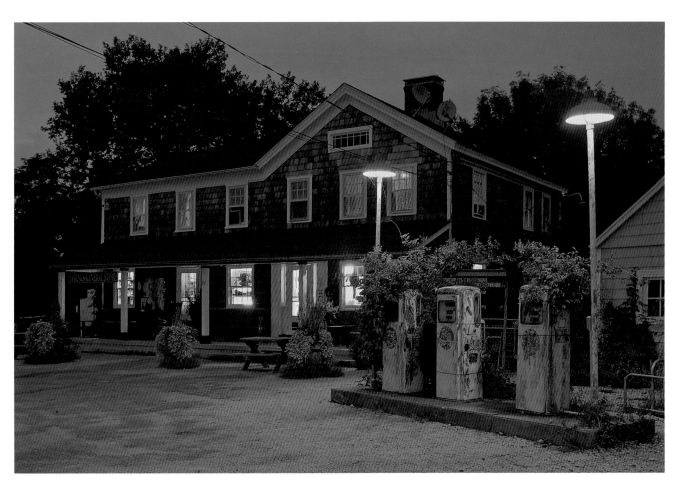

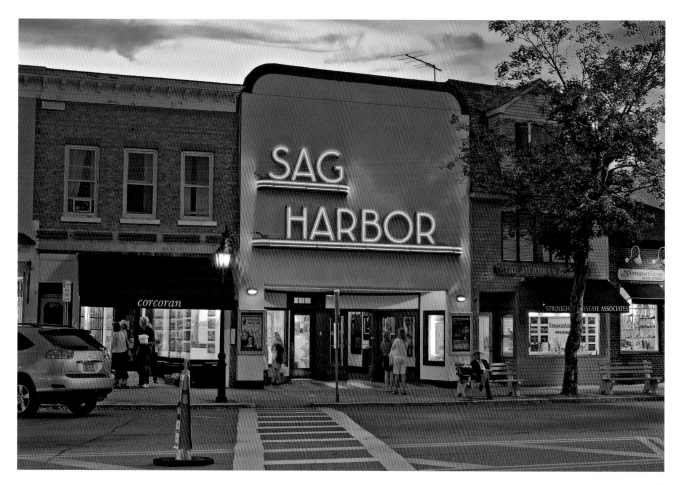

Jackson Pollock's grave, Green River Cemetery Springs
Jackson Pollack's studio Springs

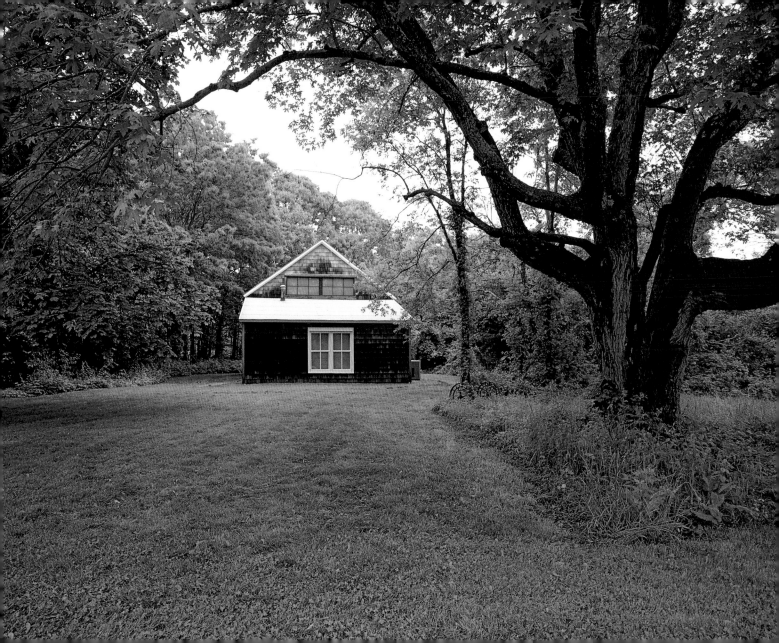

North Fork

Riverhead
Mattituck
Cutchogue
Peconic
Southold
Greenport
East Marion
Orient

Shelter Island

Shelter Island Heights
Dering Harbor

South Fork

Westhampton
Quogue
Hampton Bays
Shinnecock
Southampton
Water Mill
Bridgehampton
Sagaponack
Sag Harbor
Springs
East Hampton
Amagansett
Montauk

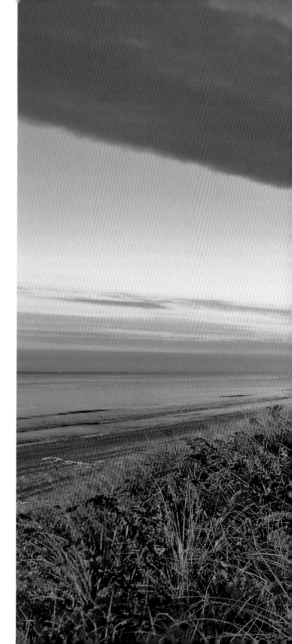

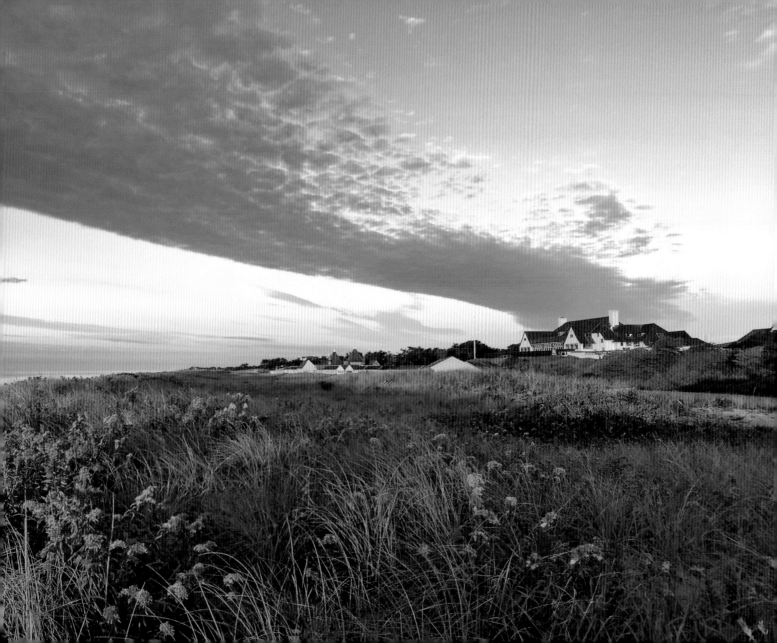

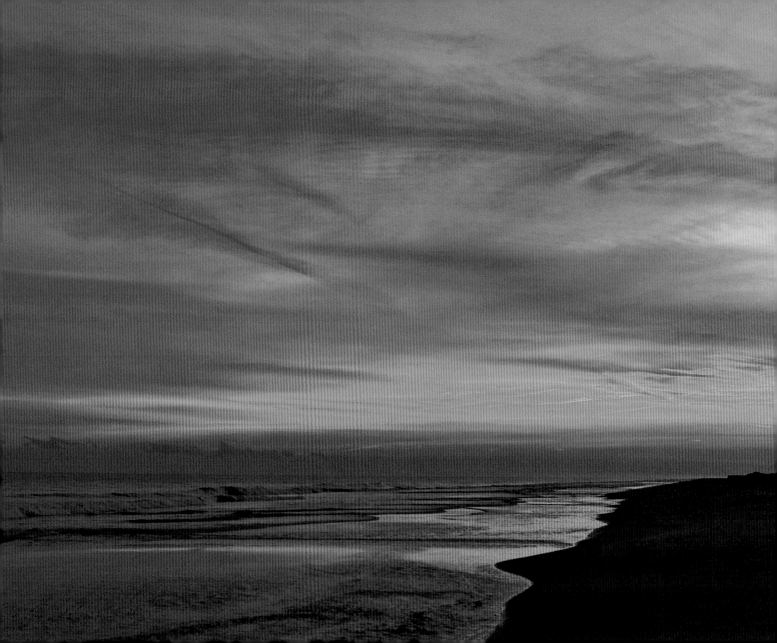

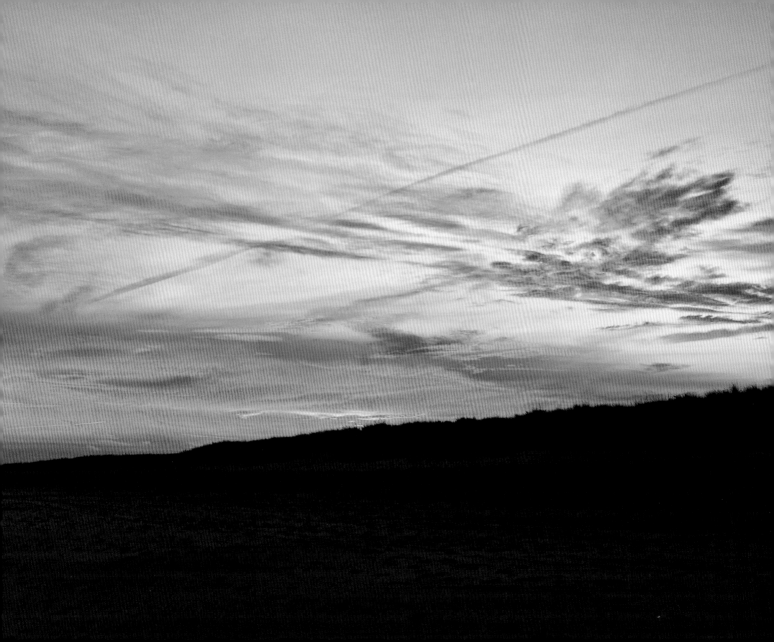

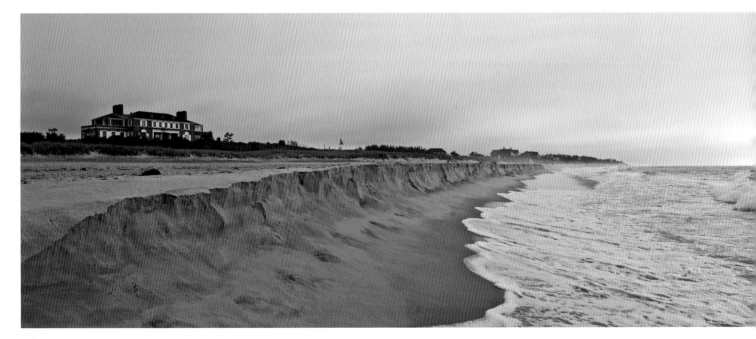

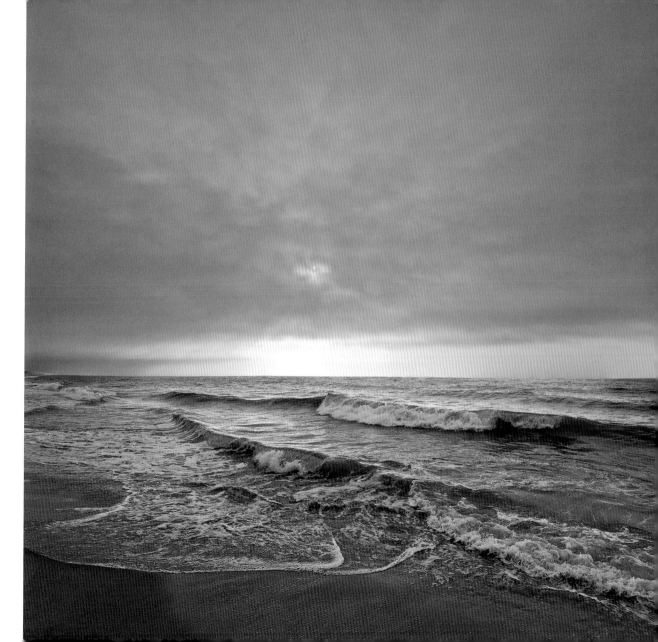

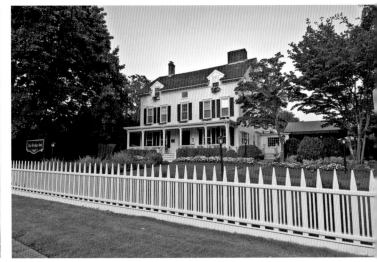

East Hampton Library
Further Lane East Hampton
Hook Mill East Hampton

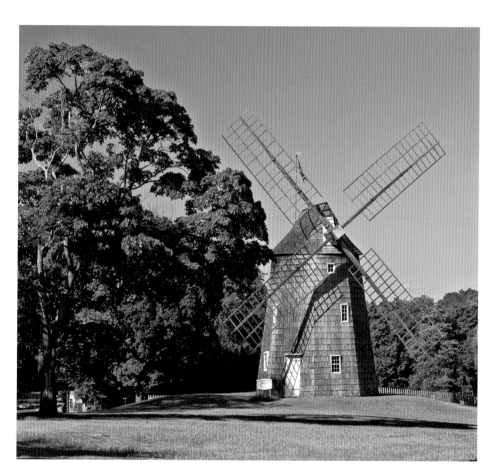

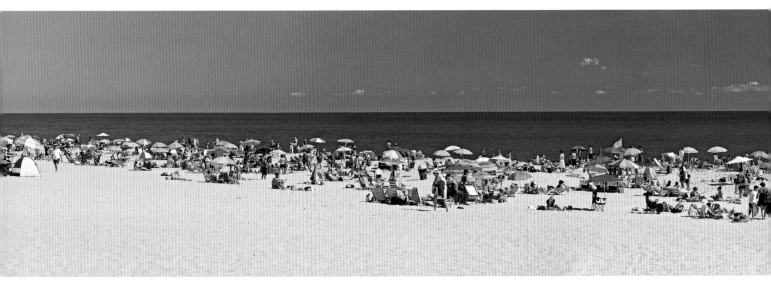

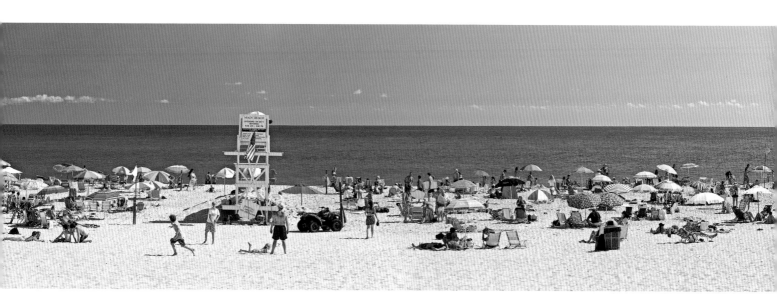

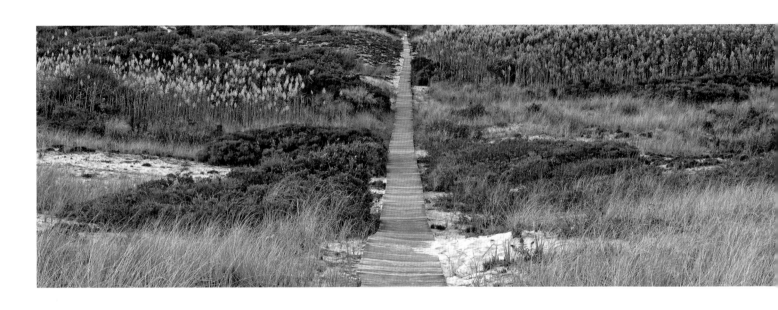

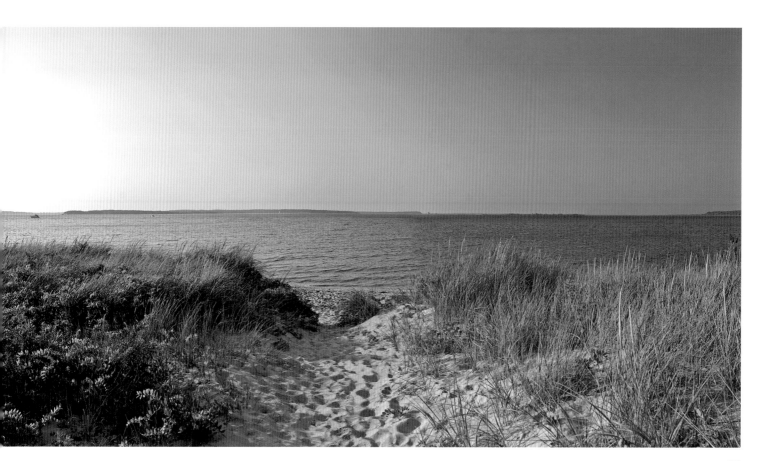

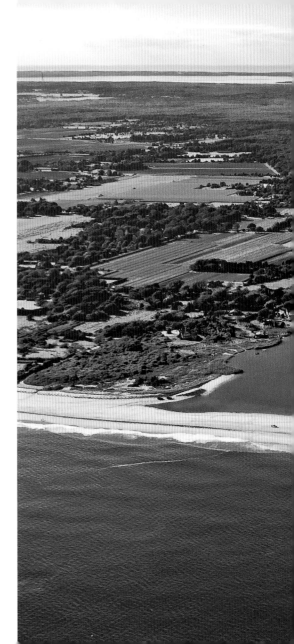

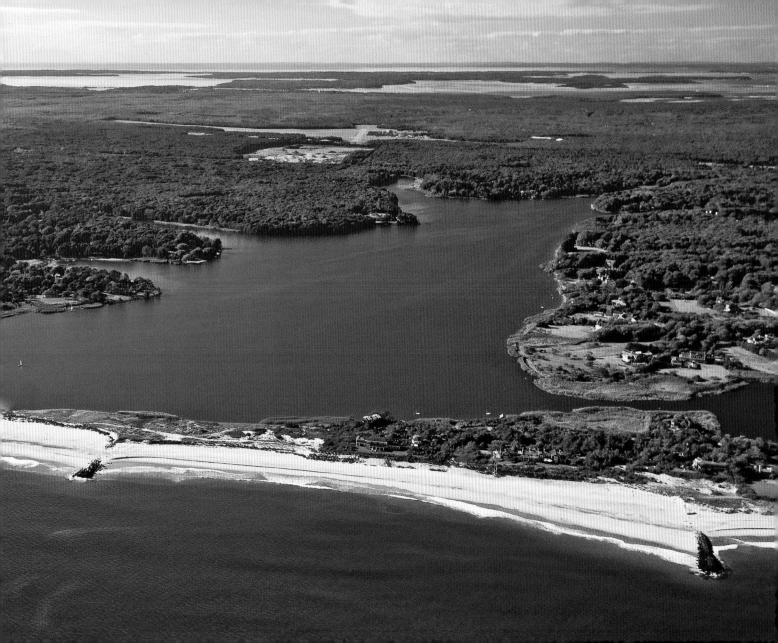

North Fork

Riverhead
Mattituck
Cutchogue
Peconic
Southold
Greenport
East Marion
Orient

Shelter Island

Shelter Island Heights
Dering Harbor

South Fork

Westhampton
Quogue
Hampton Bays
Shinnecock
Southampton
Water Mill
Bridgehampton
Sagaponack
Sag Harbor
Springs
East Hampton
Amagansett
Montauk

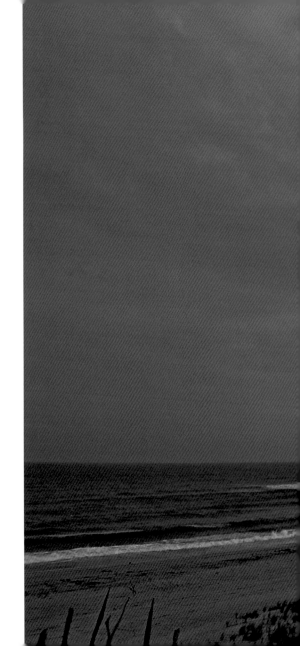

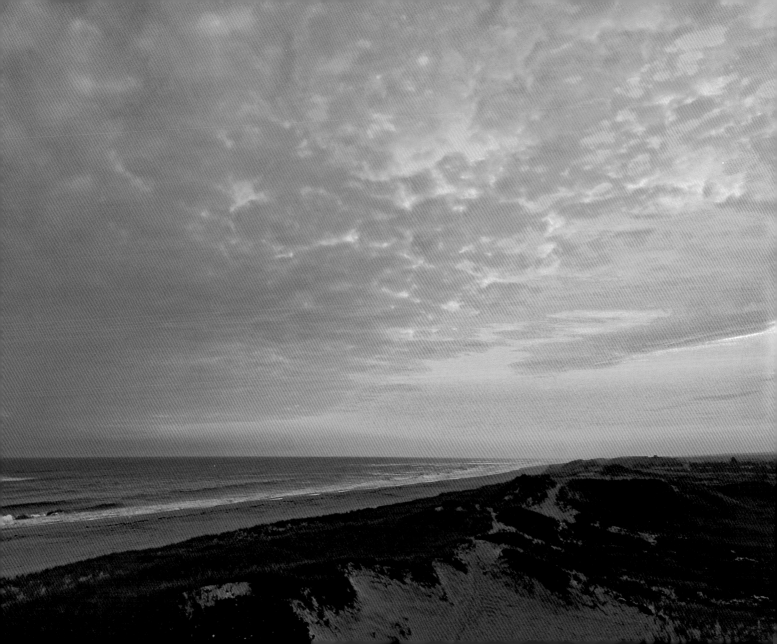

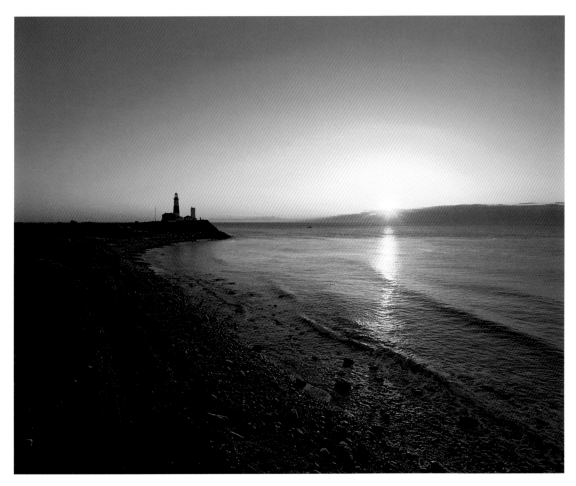

Montauk Light
Montauk

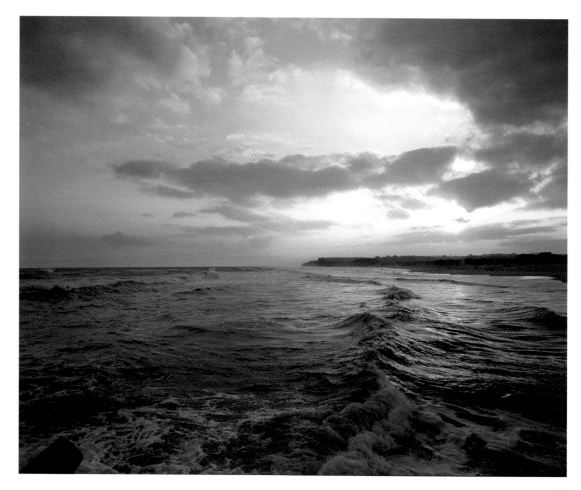

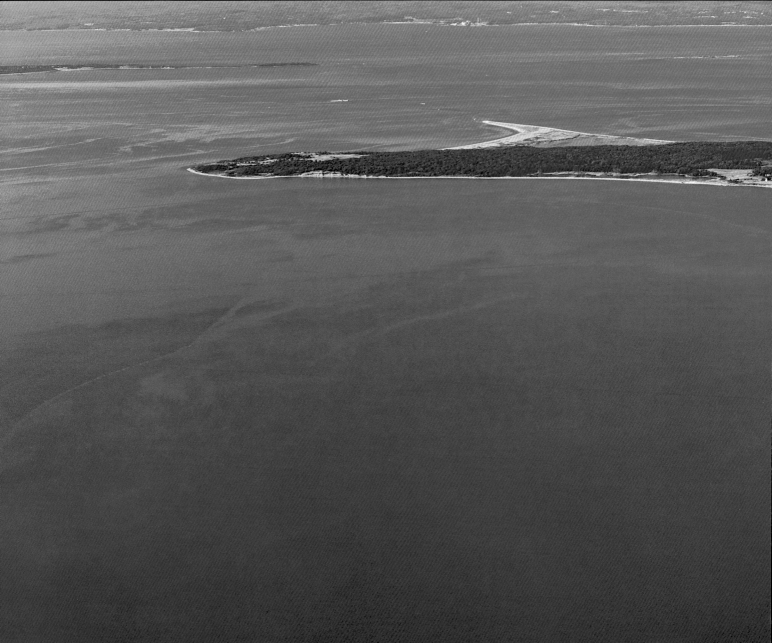

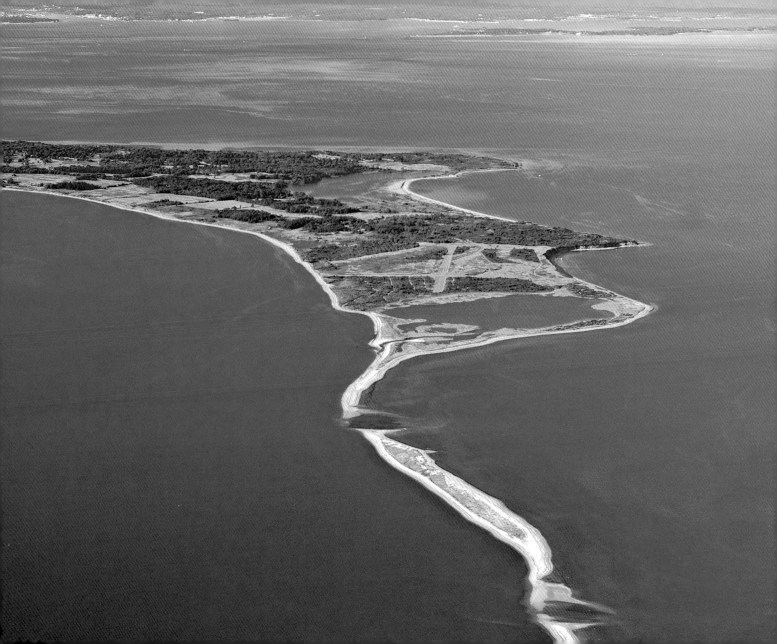

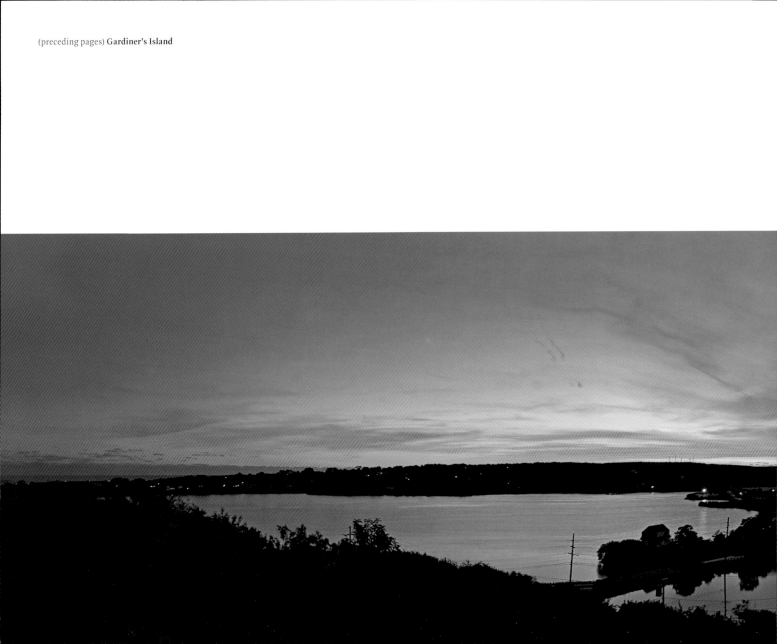

(preceding pages) **Gardiner's Island**

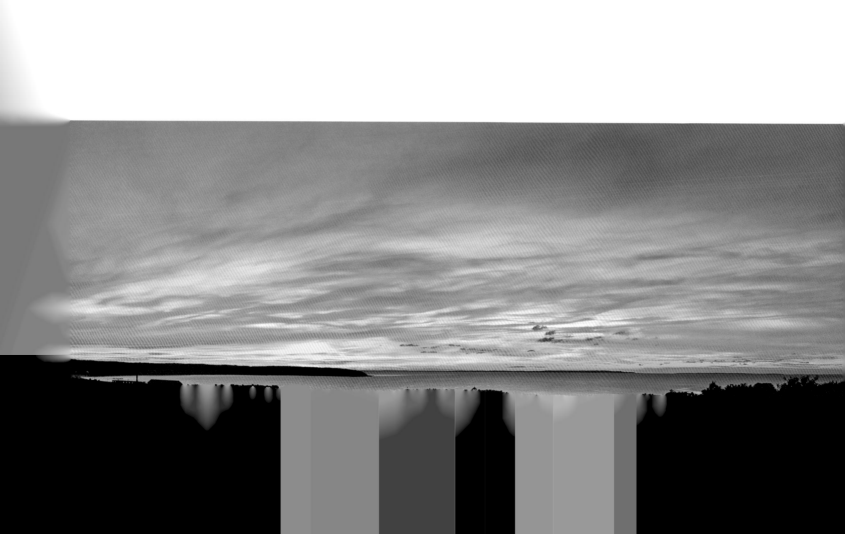

Fishing Boat Montauk

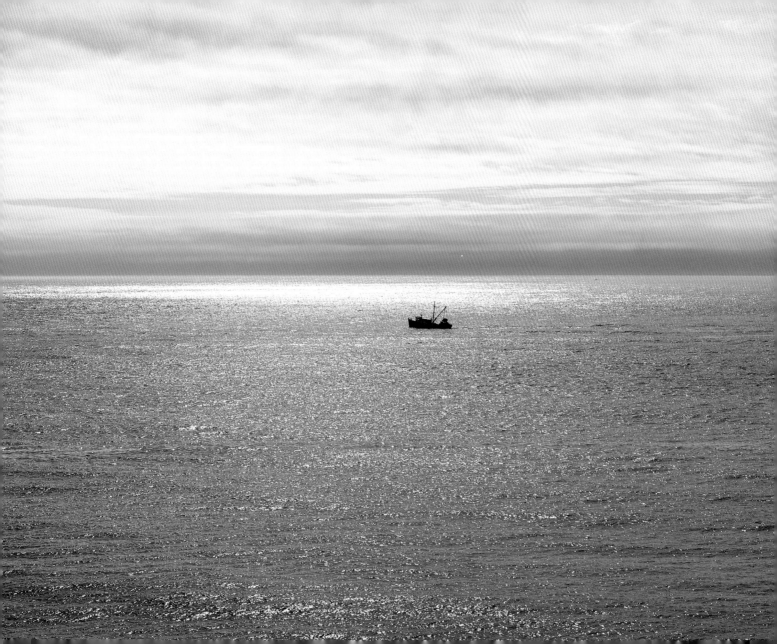

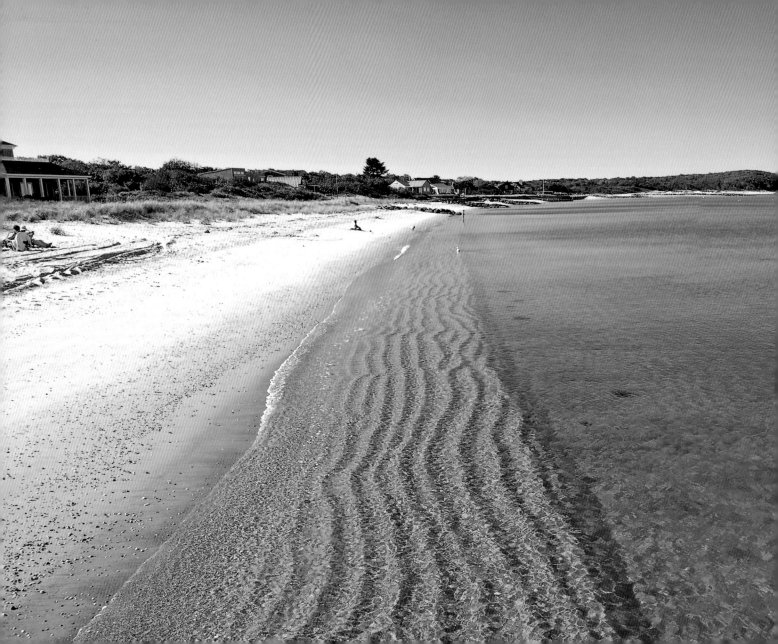

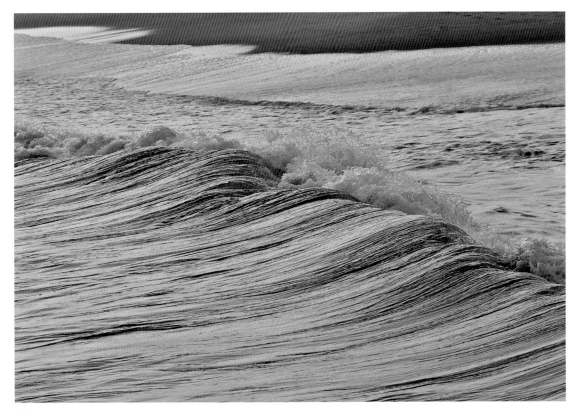

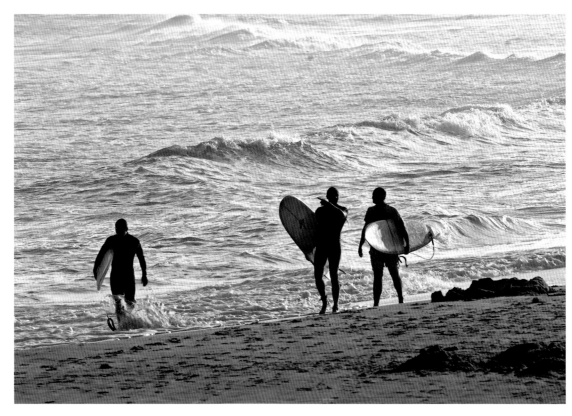

The South Fork

Paul Goldberger

Everett Rattray, the East Hampton native who edited the local newspaper, *The East Hampton Star*, until his death in 1979, described Long Island as having the shape of "a whale with a healthy trunk and skull, its forehead nuzzling Manhattan and its jaws about to bite Staten Island. The whale's flukes, the North and South Forks at the eastern end, dangle off in the distance toward Buzzard's Bay and Cape Cod in Massachusetts."

Rattray went on to observe that Montauk is closer to Boston than New York. That is more than a piece of geographical trivia. The first settlers came to this region not by journeying east across Long Island from New York, but by traveling south across the Long Island Sound from the Connecticut and New Haven colonies. Their British governors in 1648 purchased roughly 31,000 acres of the South Fork from the Montauk Indians, in part to keep the eastern end of Long Island out of the hands of the Dutch, who controlled New York. At the beginning, then, East Hampton, Southampton, and the other villages of the South Fork were outside New York City's sphere of influence.

By 1664 all of Long Island had become a part of New York State, but even then, the tie was more political than cultural or commercial. While the South Fork was not far out at sea, like Nantucket, in the seventeenth century it possessed some of the same sense of independence and isolation, and it is hard to know what more established places, if any, held the loyalty of the early settlers.

If the older village centers of East Hampton, Bridgehampton, and Southampton loosely evoke New England with their central greens, sprinkling of seventeenth-century houses, and white-clapboard churches with slender steeples, the landscape within which these villages sit is not at all like that of New England, and it is not like any other place in the United States. It is not one landscape but a collection of them, in close proximity: dunes, farmland, woods, bays, swamps, ponds, marshes, pine barrens, and a high ridge, the moraine left by the glacier that long

ago swept across the continent. At its highest point, the moraine is 250 feet above sea level, hardly a mountain, but unusually high for a place so near to the edge of the ocean. In low-lying Napeague, the land is so narrow and flat that you can see the bay and the ocean at the same time. Just a few miles away, in Montauk, the edge rises up to form majestic bluffs. At Accabonac Harbor, a part of East Hampton, wetlands and a soft, meandering bay combine to create a place of extraordinary tranquility. In Sagaponack and Bridgehampton, agricultural fields run nearly to the sea. And in Amagansett, the dune rises up behind the sandy beach, then descends as you move landward, and rises again, a remarkable undulating landscape that is, quite literally, a double dune.

The connection between New York City and the South Fork, which in so many ways gave rise to the notion of a place called "the Hamptons," is a relatively recent development. It came into being gradually through the nineteenth century, as summer tourists, encouraged by the extension of the Long Island Rail Road tracks as far as Bridgehampton, began to make their way to boarding houses and small rental cottages in the South Fork towns. The attraction for these early visitors was less the power of the ocean than the sense that they had entered a very distant, almost quaint world that seemed to exist at a much greater remove from the city than its physical distance would suggest. "Of all the places that date back to the seventeenth century, none so now retain the customs and relics of the past in their perfectness as East Hampton," wrote Henry Colton, a reporter for *Appleton's Journal*, in 1871. "Here, within

one hundred miles of New York City, is a place as dissimilar as if the great city were not; and within the quiet limits of this village, but for the telegraph wires, one might easily imagine himself in an old Puritan village of the last century."

A few prosperous New Yorkers began to build summer cottages in the 1870s, but the formal beginning of the South Fork as a landscape for significant second homes might be said to be the purchase in 1879 of the whole of Montauk for $11,000 from the Montauk Indians by a New Yorker named Arthur Benson, the investor who gave his name to Bensonhurst in Brooklyn. Benson assembled a small group of other wealthy New Yorkers and convinced Stanford White to design a cluster of houses and a clubhouse that they could use as rustic, or semi-rustic, escapes for hunting and fishing. Eight of White's houses, which were called the Montauk Association, were built. Seven of them remain there today, not the very first summer villas, but the ones that mark the most ambitious beginning of the South Fork's life as a resort.

Still, for all the audacity of Benson's acquisition, New Yorkers did not really make their mark on the South Fork until the 1890s, when the Long Island Rail Road extended its tracks from Bridgehampton to Montauk. While a spur line to Sag Harbor had been built in 1869, it existed mainly to serve the commercial needs of Sag Harbor, an active trading center and, until the whaling business disappeared, an important whaling port. There was very different commercial impetus for bringing the railroad all the way to the end of Long Island. Austin Corbin, who

became president of the Long Island Rail Road in 1881, believed that Montauk, a full day closer to Europe by sea, made much more sense than New York City as the American terminus for transatlantic steamships. Corbin foresaw a day when passengers would disembark at Montauk and happily board his railroad, grateful to exchange a full day at sea for three hours on a train. It took Corbin several years to assemble the land for the right-of-way through East Hampton and Amagansett all the way to Montauk—most of the land east of East Hampton village at that point was used for grazing sheep and cattle—and it took until the end of 1895 before the railroad was operating to the end of the island. Montauk never achieved even a hint of Corbin's hope that it would become a major port-of-entry, but the effect of the railroad on the rest of the South Fork was profound. It was not the effect Corbin had intended. Both Southampton and East Hampton became favored locations for gentry from New York and elsewhere seeking a summer place by the sea, and if neither town ever developed the cachet of Newport, the size and scale of many of the grander estates built in those years suggests that Southampton, at least, was not far behind. By the end of the first decade of the twentieth century, both towns had come to possess a significant stock of sumptuous summer "cottages," mainly in the shingle style. East Hampton's shingle style houses, a great many of which remain, constitute one of the finest inventories of this American architecture style anywhere.

The early summer colonies, however, were just that—colonies—sitting within what was still, for all intents and purposes, a different world. In East Hampton, the original summer colony of expansive, shingled houses was almost entirely at the west end of the village, between Georgica Pond and the village center. In Southampton, the summer villas mostly faced Lake Agawam, between the ocean and the village's center, or lined surrounding streets. Huge sections of both towns were left untouched by the newcomers. In East Hampton, the more northern sections were wooded, and lightly settled, largely by fishermen, although there were clusters of farmers in small village settlements like the Springs. Much of East Hampton's farmland was on the eastern side of the village, a mile or two beyond the summer colony. While one wealthy family, the Wiborgs, did purchase a huge tract of oceanfront land southeast of the village center—much of which eventually became the Maidstone Club—the eastern end of East Hampton remained largely rural until well after World War II.

That was even more the case in Bridgehampton and its neighboring hamlets of Sagaponack and Water Mill, which had a scattering of summer villas but were primarily rural until fairly late in the twentieth century. Their economies were based mainly on farming and fishing, their landscape defined less by any man-made construction than by the extraordinary vista of fields running from the village center all the way to the ocean, a distance of several miles punctuated by the occasional farmhouse or, in the case of Sagaponack, a one-room schoolhouse. Even in Southampton, which had and continues to have the largest commercial center, a few bits and pieces of farmland at the village edge

were visible all the way through the twentieth century.

Now, no one could think of the South Fork as primarily agricultural, even though hundreds of acres remain actively farmed, and the roadsides are filled with farm stands that in the summer overflow with local produce. But the larger trend is only in one direction, from open land to more and more building, and over the last generation, the question of development has come to preoccupy this region. It connects to everything: to the culture, to the economy, to environmental issues, to politics.

In Bridgehampton, Sagaponack, Water Mill, and Wainscott, where once the fields ran down to the sea, now it is the houses that dominate the landscape. That is true in the larger villages of Southampton and East Hampton too, but since they are older and their landscapes more heavily populated with trees, it is harder there to see how much their density has increased in the last generation. In East Hampton and Amagansett, the problem now is with people tearing down medium-sized houses and putting up McMansions on relatively small lots. In Bridgehampton, Sagaponack, Water Mill, and Wainscott, the problem is with people putting up houses in the first place—building where, until recently, there was nothing at all, save for corn and potatoes and zucchini and sunflowers. Either way, there are more and more people, and there is less and less open space.

The towns of the South Fork are not alone in facing what we might call the challenge of prosperity.

They share it with plenty of other American communities that have become attractive to people with new money, places like Nantucket, Aspen, Vail, Santa Fe, Santa Barbara, Martha's Vineyard, and Carmel, trophy towns that are simultaneously blessed and cursed with an affluence that has washed like a tsunami over them and, in the name of love and affection for these places, put their survival in jeopardy by shoehorning more and more people in, making everything more expensive, more crowded, and more agitated.

What is the solution? Nantucket has been a pioneer at putting land in public trust, and in using real estate transfer taxes to assist in the purchase of land for preservation. Over the last generation, East Hampton and Southampton have begun to play catch-up, and hundreds of acres have been protected from development either by community purchase, often from funds provided by a real estate transfer tax based on the Nantucket model, or by donation to the Nature Conservancy or the Peconic Land Trust, each of which has acquired significant permanent holdings on the South Fork. The land acquired by these private non-profit organizations has generally been in the form of either very large parcels or landscapes of unusual importance, either as natural habitats and refuges, or areas with critical views. The real estate transfer tax has been a boon to a less glamorous form of land preservation in recent years, allowing the towns to save parcels of more conventional land, either agricultural land or wooded acreage that had been threatened with subdivision development. And an innovative program by which

the government purchases farmland development rights in exchange for a commitment that land will remain in active agricultural production has had the double benefit of protecting land from overdevelopment and helping to support the local farmers. All of this is cause for optimism: several concurrent land conservation systems are in place, and all of them are working. But for all the recent successes, it is also true that since the South Fork came late to the game of land conservation, much of the damage has been done: open space once lost is, after all, almost never regained.

There is no easy answer to this paradox, but it does force us to confront the question of how much architecture matters to the future of the South Fork, and whether, for all the glory of the region's architectural heritage, in the twenty-first century building may be as much a part of the problem as a part of the solution. It is hard not to think that what the South Fork needs now is simple, plain, and affordable housing on the one hand, and open space and land conservation on the other.

Oversized new houses with lots of rooms, lots of garage space, lots of plumbing, and lots of technology, all wrapped up in pseudo–shingle style or pseudo-colonial or pseudo-Tudor or pseudo–French Renaissance architectural garb, are not unique to the South Fork, of course. But they raise a vexing question in an area with as rich an architectural heritage as this one: are they part of the area's tradition, or a violation of it? Modesty may have characterized the architecture of the region in its

colonial beginnings in the seventeenth and eighteenth centuries. But there were far grander ambitions to the great, shingled cottages of the early summer colony. And given that the majority of the large new houses on the South Fork today are attempts by architects to work again in the shingle style and to pay homage to the great houses of a century ago, is it fair to say that the newest wave of huge houses represents a break with the area's traditions?

Yet several things distinguish the latest shingled houses from the older buildings that are their inspiration. Almost all of the great houses of the first generation were original, and masterly, compositions, inventive explorations of what was then a new and fresh vocabulary. Most of the neo–shingle style houses being built on the South Fork now lack the creative spark that marked their predecessors, and some are little more than copies of admired older buildings.

The first generation of expansive, shingled houses was built near the ocean but almost never at its edge. In those early years, builders placed houses a respectful distance from the dunes; for all their grandeur, the shingle style manses of the late nineteenth century addressed the ocean with a certain deference. They did not so much challenge it as stand humbly before it.

But the most important distinction between the great shingle style models and the new houses is sheer quantity. Once, the old houses were a rare, and precious, commodity, clustered in the villages under great trees on gentle streets that played off against

the ocean and the open fields. Now, their imitations are everywhere, one after the other in a manner that, however much it may be intended to evoke the feeling of the original summer colonies, seems more to call to mind suburban sprawl.

Paradoxically, the architecture that now appears modest and understated and at home in the landscape of the South Fork today isn't the shingle style but the modern houses. Many of them, by now, are part of the area's history, too, since they date from the 1950s and '60s, decades when architects such as Pierre Chareau, Peter Blake, Andrew Geller, Robert Rosenberg, Charles Gwathmey, Julian and Barbara Neski, Norman Jaffe, and Richard Meier made the area one of the nation's most fertile environments for the development of modern residential architecture.

Their work formed a welcome parallel to that of the modern artists like Jackson Pollock, Willem de Kooning, Ad Reinhardt, and John Chamberlain who had settled on the South Fork and continued an artistic tradition begun long ago by Childe Hassam and Thomas Moran, among others—artists drawn by the beauty of the natural landscape, to be sure, but even more by the extraordinary silvery light that, at once warm and crisp, washes over both land and sea.

The modern architects coming to the South Fork in those years had no more use for the older houses than the abstract painters had for Childe Hassam. The shingled manses were disdained for both their style and their size. Almost everything the new generation built on the South Fork was modern and small—pavilions as much as villas, weekend houses for a sophisticated middle class that identified not at all with the life the old summer colony symbolized. By the late 1970s, modern houses had become plentiful—very plentiful—and the process of cutting up the old farm fields was well underway. But year by year, or so it seemed, the modern forms became less serene and more sculptural, their architects less concerned with the restraint that had characterized the beginning of the modernist wave, and more inclined toward what came to be described, not always positively, as "making a statement." As the houses crept up in size, their abstract shapes all the more conspicuous the bigger they got, the real risk in the region was cacophony.

It seemed almost a relief when several talented architects—Robert A. M. Stern and Jaquelin Robertson among them—began to look again at the old shingled houses, not as historical artifacts but as sources of inspiration. While the architecture of the South Fork had never been characterized by a single style in the manner of the adobe of Santa Fe or the Spanish Mediterranean of Santa Barbara, the shingle style seemed to evoke a spirit that most people associated with Southampton and East Hampton, and it held the promise of bringing some order to a landscape that seemed, after decades of active building with relatively little overall planning, to be descending into chaos. But then, as the affluence of the 1990s brought more and more people to the South Fork, the shingle style houses replicated even faster than the modern ones had, and with even less originality. The inventiveness that had characterized both the early shingle style houses and the modern ones became scarce. And all the while the land

continued to disappear. By the turn of the new century, if the South Fork was at risk of being taken over by any architectural cliché, it was not the abstract shapes of modernism, but the more traditional shingle style.

And yet, for all that has happened, there is something about the South Fork today that is nothing short of miraculous, still. Seaside places everywhere have always been crowded, and it is possible to look at this one, among the most beautiful of them all, and be amazed not that it is congested, but that it is not more built up than it is. The South Fork is, after all, a hundred miles from New York City, a source of money and extraordinary development pressures. Perhaps it is better to look at the South Fork this way: it has no boardwalks, no commercial strips, and no high-rise condominiums. There are barely any condominiums at all, and no large resort hotels. Most of the hotels are bed-and-breakfasts. There are several new golf courses, but each of them could have been several dozen more houses instead. Many of the most important features of the natural landscape—the double dune in Amagansett, the wetlands around Accabonac Harbor, the bluffs in Montauk, forests in Southampton—are now protected from development.

In many ways the South Fork has held its own rather better than its residents and its natives often give it credit for doing. It isn't that all is well, or that the next generation will not have an even more difficult time keeping the place intact than the last generation has. But if you visited the South Fork now for the first time, with no memory of how it was ten or twenty or thirty years ago, I suspect your first reaction would not be how ruined it is, but how wonderful it is. The essence of the place, the extraordinary way in which the sea meets the land and yields a whole range of precious landscapes, remains. And the South Fork is, in the end, a real place, as it must be—a place where people not only vacation but live and work, which requires a community that is willing to grow, and accepting of change. The challenge is not to freeze the South Fork exactly as it is, or to bring it back to something it once was—either of these are doomed to fail, as much as any attempt to turn it into a precious, make-believe creation that is an idealized version of a seaside village that never was. The challenge facing the South Fork now is to hold onto all that makes it remarkable and beautiful, to preserve its great land and open space, and at the same time to keep alive the spirit of creativity and the belief in the new that have engaged its citizens for more than three centuries.

Published in the United States by The Monacelli Press,
a division of Random House, Inc., New York

The Monacelli Press and the M design are registered
trademarks of Random House, Inc.

Library of Congress Control Number 2011920255
ISBN 978-158093-315-5

10 9 8 7 6 5 4 3 2 1

Printed in China
Designed by David Blankenship

www.monacellipress.com